WORKING FIRE

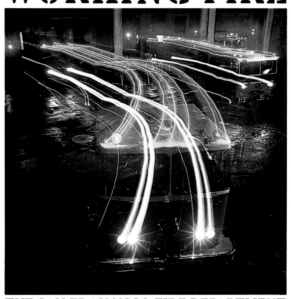

THE SAN FRANCISCO FIRE DEPARTMENT

WORKING FIRE

Photography by
GEORGE HALL

Text by
JOHN BURKS

Design by
GEORGIA GILLFILLAN
and
PHIL CARROLL

CHRONICLE BOOKS • SAN FRANCISCO

THE SAN FRANCISCO FIRE DEPARTMENT

First published in paperback 1985 by

Chronicle Books
One Hallidie Plaza
San Francisco, CA 94102

Photographs copyright © 1982 by George Hall
Text copyright © 1982 by John Burks

Library of Congress Cataloging in Publication Data
Hall, George (George N.)
 Working fire.

 1. San Francisco (Calif.). Fire Dept.
2. San Francisco (Calif.)—Fires and fire prevention.
I. Burks, John. II. Title.
TH9505.S37071H35 1985 363.3'78'0979461 84-23254
ISBN 0-87701-352-7 (pbk.)

Additional photography: p. 5, 61: Chet Born/SFFD; p. 18, 20
left, 22, 26, 27, 28: California Historical Society; p. 20 right:
Firemen's Fund collection; p. 23: Arnold Genthe/California
Historical Society; p. 46 center: Rich Hansen/SFFD.

Color prints are available from the photographer.
For information write George Hall,
82 Macondray Lane, San Francisco 94133.

Typesetting: Turnaround, San Francisco

Design: Georgia Gillfillan, Phil Carroll

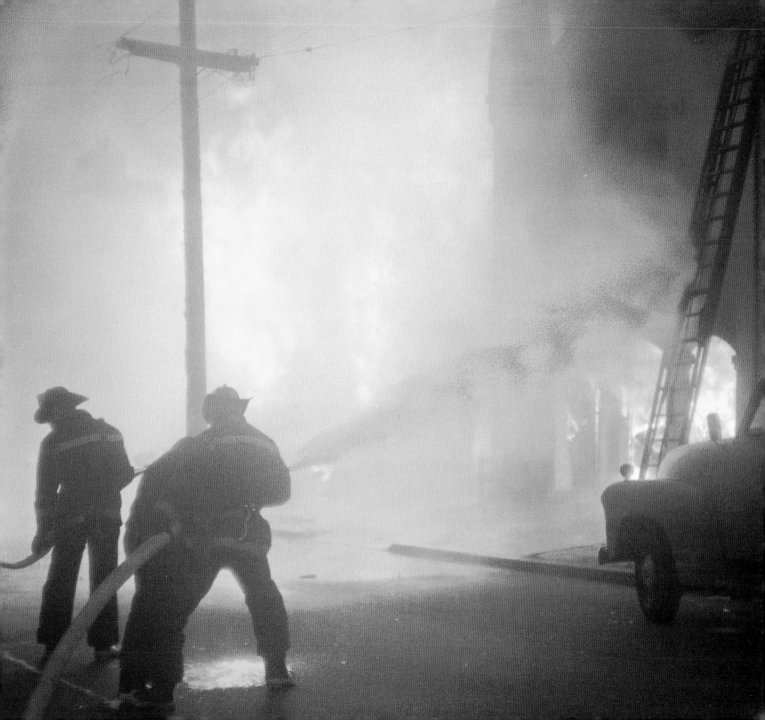

A Note from the Photographer

In a very general way, I had been thinking about shooting a book on firemen—the chances they take, the fires they fight—for years. No question that there were dramatic photos to be taken of these heroes in their throwback leather helmets and turnout coats, armed with axes and ladders and hoselines. The billowing flames, the swirling smoke, the glow in the sky from across the city... The idea lived mainly in the back of my mind until one May weeknight in 1977, when a big fire broke out right next door to my place on Macondray Lane in San Francisco.

Macondray has to be one of the toughest places in the city to fight a fire. Even to call it a "lane" is a bit of a joke. At one end, Macondray is nothing but a 40-foot driveway. At the other end is a steep wooden staircase leading from street level to a winding stone pathway. There is no way to bring a fire engine into Macondray and park in front of the middle two buildings—which, on this evening, happened to be aflame. This was no simple oven fire. It went to three alarms, and extensive damage was done before the San Francisco Fire Department extinguished it.

I was fascinated, bemused. If this fire could not be controlled, I might lose all my life's possessions, most important being irreplaceable photos and negatives and transparencies. But I was less panicky than I was enrapt,

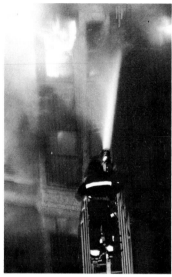

impressed by how competently the fire department took care of business. Up the staircase came a platoon of firefighters bearing hose bundles, axes, and all manner of fire tools, while others clambered over the adjacent rooftops with their gear. There was no wasted motion, no fumbling, no indecisiveness, not even much shouting or orders being given. It was as if they had drilled on Macondray. These people clearly knew exactly what they were doing.

Later that night, I went down to Station Two in Chinatown to express my appreciation to the first-due battalion chief, a gent named Flaherty. It seemed clear, I told him, that he and his men had given some serious thought to

how they'd go about fighting a fire on Macondray Lane. "Yep," Flaherty acknowledged, "that's one of the worst places in my district to have a fire." He told me how he had eyeballed Macondray for years, how he'd figured on having to bring hose leads over the roofs from Union Street below.

The more we talked, the better I understood that San Francisco is one of the most challenging cities in the world for firefighters. The hills . . . varying water pressures . . . narrow streets . . . predominantly wooden buildings abutting each other with little or no space in between . . . dangerous exposures . . . difficult access . . . and underlying it all, the ever-present potential for an earthquake which could, as happened in 1906, turn most of the city into a fiery nightmare. That night I knew I would do this book.

The next stop was Fire Chief Andrew Casper's office. He was totally cooperative and encouraging about my project, and he was making arrangements to have me stay at the firehouses and ride the rigs almost before I knew it. In fact I had dinner that same night with everyone at 38 Engine in Pacific Heights; I told them about the book, put away dessert, and *beep-boop*, everybody was due at a working fire in Polk Gulch! Chief Don Brady yelled for a second alarm almost as soon as he hit California Street,

and I jumped into the service squad truck and tore off to the fire. It was a Victorian three-flat with the whole top floor involved; from Gough Street it looked like a huge neon sign in the skyline. Next thing I knew I was shooting like mad and thinking what a cinch photographing this book was going to be.

Of course, in over a hundred nights spent at firehouses around town, that was almost the only time things happened that dramatically. I became accustomed to the more typical rhythm of things: long stretches of quiet, interrupted by "stills" for medical problems, rubbish fires, lockouts and eternally maddening false alarms. I don't think there's anything quite as tiring as stumbling out of bed ten times in a night—at agonizing 40-minute intervals—to chase down a string of false boxes, apparently pulled by the same person. It's probably a good thing we never got our hands on him.

I also got to know the firefighters—how they work, what they think, how much they love doing their job. Most firefighters are great people to know, regardless of whether you have much in common with them. They tend to be Catholic, conservative, Sacred Heart grads who played football, basketball *and* baseball; they're usually family guys living in Novato or Pacifica. Basically they're wonderful people, very positive about life, who like other people and care about them. They feel very fortunate to be firemen and now I know why.

It is dangerous work. Few die on the job, but they get hurt almost routinely—burns, cuts, sprains. They get injured more often than policemen, but fire work is probably healthier for the mind than police work. Firefighters are up against a mindless, implacable foe, everybody's enemy. There's great nobility and satisfaction in fighting fire and saving lives.

Cops have a terrible time catching the bad guy and actually putting him away. In contrast, firefighters roll up and put out the fire in a fearsome struggle; they apprehend the "bad guy" and do away with it on the spot—delicious summary justice. It's no wonder that cops often mask their feelings with black humor that seems so callous to people outside police work.

Firefighting is just the opposite. It's very life-enhancing, because there's a great emotional lift in going up against the monstrous enemy and defeating it. It's an almost luxurious form of heroism. Perhaps that's why 8000 people sign up to take the test for a handful of firefighting jobs; it's certainly why dozens of police-

men have switched over to the SFFD, while it's almost unheard-of for a San Francisco fireman to switch to the cops.

Since there are some 1500 gentlemen connected with the SFFD, it is impossible for John and me to extend our thanks to each person who assisted us. Suffice it to say that everyone from Chiefs Casper and Condon down to the newest probie was totally helpful and cooperative. Chief Emeritus Bill Murray regaled us with hours of fascinating recollections of his half-century in the SFFD. Special thanks must go to the folks at Stations Three, Seven, Eight, 36, and 38 for putting up so good-naturedly with our repeated invasions of their privacy. And to the Alley Cats of Station One, with whom I rode on so many nights, I owe a debt that I can never repay.

——George Hall

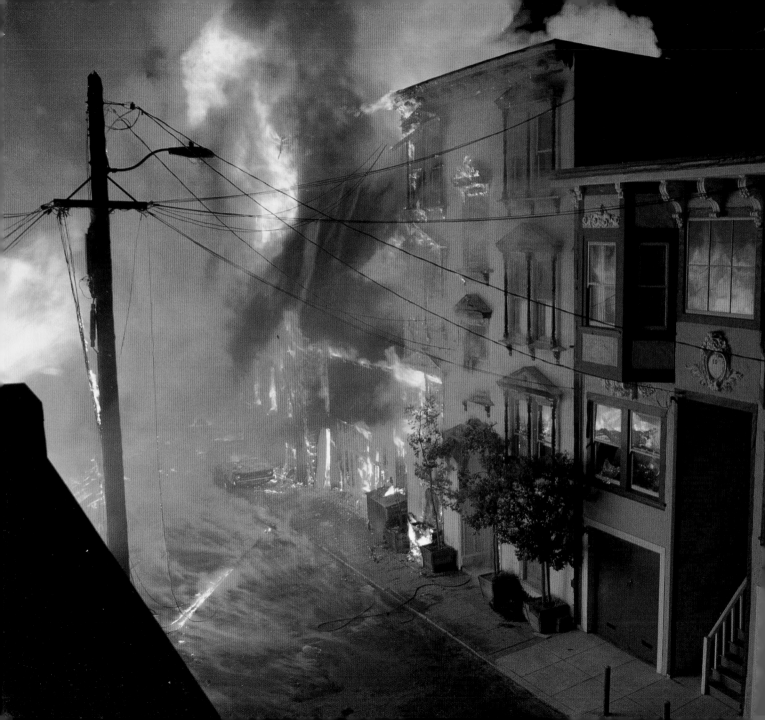

THE BIGGEST FIRE SINCE '06

The Folsom Street Fire took off like a box of kindling

The alarm was struck at 2:15 am. First to arrive about two minutes later was One Truck, rolling in from Station One, half a dozen blocks away. "We saw we had a large fire in progress," said Lt. Charlie Krieger. "First thing I did when we saw the scope of it was to notify Communications that we had a working fire.

"As I reached Seventh Street a block away, I knew we'd need more help, so I ordered a second alarm. We parked the rig right in front of the burning building, which used to be a gay bathhouse and was being remodeled. I could see there was an exposure hazard, which means that the fire is spreading and our first job is not to try to put it out but to confine it. *Then* put it out. We set up an aerial right away, a ladder pipe with the big nozzle at the top of the ladder, to try to confine it."

When the first alarm went on the air, Don Frediani was watching a late-night movie on TV. He had the night watch at Station 36. Since his house was not due to respond on the first alarm, Frediani did not stir. But when the radio continued squawking, Frediani paid closer attention. "Maybe ten seconds after the first alarm they came on and said they were getting lots of phone calls on this one, so I knew something *real* was going on out there. There are lots of false alarms in that part of town—it's hit and miss, you know—but I've been to some damn good fires down there, and this began to sound like it might be the next one."

Then Charlie Krieger's voice called out "working fire." The

urgency in Krieger's voice, almost a howl, told Frediani he'd better start waking everyone up at Station 36. Located near City Hall, 36 Engine was due to respond on the second alarm; there was no harm in alerting the men that they were about to swing into action. "I just felt it," Frediani recalled. He woke up his men with a whoop and seconds later, at 2:18, the second alarm sounded.

Hearing the same ominous radio traffic, firefighters all over

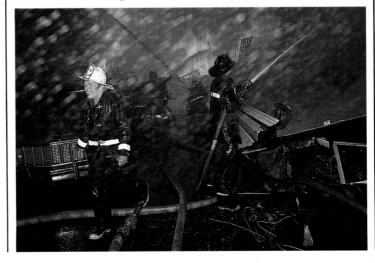

town began to stir. Some of the veterans, thinking back to earlier engagements that went on for hours, made a beeline for the boys' room before anything else.

In seconds, the men of 36 Engine were suited up, down the pole, and on the rig, even as they shook off their slumber. Siren howling, 36 Engine raced down Oak Street to Van Ness, then charged across Market. "We hit Tenth Street and I could see the glow lighting up the sky," said Frediani. "From several blocks away on Folsom, I could see the flames shooting in the air." It reminded him of the most enormous blaze he'd ever seen—the 1975 Gartland Apartment fire. But this was bigger. Several buildings burning, a whole block maybe, and far more flame. The engine stopped half a block from the burning Globe Hotel, which by now was almost completely consumed by the red and orange flames roaring from inside. The heat was fierce.

While two men of 36 Engine began leading to a hydrant, Frediani hurried over to One Truck, immediately in front of the blazing Globe. "Charlie Krieger said to run a big line up onto the next building over, so I took a line up a 35-foot ladder. I'm three quarters of the way up when—loud as hell, *very* loud—I hear this explosion. The damn building had fallen in, collapsed right beside me, and at first I didn't know what had happened. The ladder bounced back off the wall a good three feet. I've heard explosions before. I wasn't scared until I looked over to the left and saw nothing but fire, no building there at all, just all the fire in the world. That's when I'm thinking: 'Hey, this might be a good time to get down from here.'"

With the Globe's walls blown out and the roof caved in, flames shot high into the night sky, licking at Frediani and at Ron Barney, who was suspended over the Globe on One Truck's ladder pipe. "Suddenly," Barney recalled, "the whole building just shuddered and collapsed, taking a telephone pole with it. And I'm taking all this heat; I'm like a marshmallow on a stick."

The explosion knocked Lt. Krieger and several others off of One Truck. Now they scrambled to regain their footing as Frediani tried to scuttle down his steaming ladder and Barney, suspended directly over the raging fire, began to scream: "Get me down! Get me down! I'm burning! Get me down!" One man clambered to the truck's turntable and rotated the aerial, swinging Barney away from the heat and flame.

Left: Ron Barney, left, and Charlie Krieger, right, take a breather and discuss the conflagration with Chiefs Casper (white coat) and Condon. Right: Firefighters clamber over roofs to the south of Brush Place.

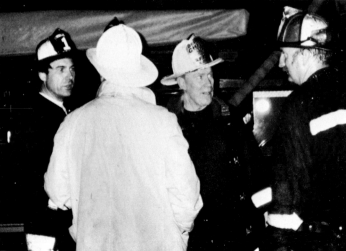

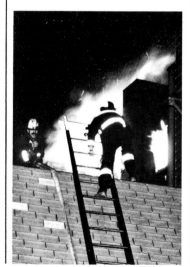

Krieger jumped to his feet just as Frediani was losing hold of his steaming ladder. Frediani misstepped, now was falling—yelling as he fell—toward the sidewalk 15 feet below. Krieger dashed to the spot and Frediani landed directly in his arms, the two of them falling to the ground on impact. Frediani rolled out in a somersault, further cushioning the fall. He picked himself up off the wet street, thanking his maker he'd not fallen into the fire.

Barney was on the street now, safe but still screaming. "I mean, I was pissed," he remembered. "It was nobody's fault, that's just the way things happened."

Krieger told him to shut up and get his act together.

A few feet away, Frediani was taking stock. All he had lost was his helmet. He wasn't hurt at all—no pain, no blood, nothing twisted. "Charlie couldn't believe I wasn't hurt, and Timmy Miles, the officer on Three Truck that night, came up and said: 'Pal, you got eight lives left.' They'd seen the explosion and me falling and couldn't believe I was in one piece. I never really thought about it the rest of the night. Now it was us against it. I wanted to get back to fighting the fire." Somebody handed him his helmet; he jammed it back on and battled the blaze until dawn.

Ron Barney barely caught his breath before climbing back to the top of the ladder and resuming his fight.

It never occurred to either man to take a break, let alone take the rest of the night off.

From street level, Charlie Krieger had assumed the extent of the problem was the Globe Hotel and the buildings immediately adjacent. But when he mounted the aerial ladder behind Barney, he saw at least ten buildings on fire behind and beyond the Globe, down the alley. "Holy Christ," he told himself, "red hot back there. This thing is awesome."

Later, Chief Andrew Casper would call the Folsom Street Fire a conflagration, an event vastly more menacing than a mere fire, both because of its volume and because of its terrifying unpredictability. Casper allowed that if the breaks had gone against them that night, it might have grown into a full-scale firestorm, an uncontrollable monster of the sort that swept San Francisco after the '06 Earthquake, capable of swallowing whole blocks at a gulp.

Casper had arrived at 2:25, ten minutes after the first alarm, and the situation looked dire. He requested a fourth alarm immediately and a fifth at 2:32. This meant that 37 pieces of rolling stock had been summoned, each fully manned. In the hour that followed, Casper put out four additional "special calls" for more rigs and men, amounting to an unofficial sixth alarm and then some. Ultimately on hand were 23 fire engines, nine fire trucks, three attack hose tenders, a rescue squad, several support rigs and nearly 225 men.

Following standard procedure, Casper sent his number two man, Deputy Chief Emmet Condon, to the rear of the fire for reports from that vantage point. He communicated with his other chiefs at key peripheral locations by walkietalkie. "Within a half hour," said Casper, "we knew we were fighting a losing battle. The fire was simply progressing; we couldn't hold it in check. One of the reasons was that PG&E couldn't shut off the gas—turned out their map of gas mains was outdated."

Finally, PG&E brought in a trench digger to cut into the street, locate the main gas line leading down Hallam Street, and shut it off. "Until they did that, the gas was feeding the fire and we couldn't control it. We really didn't know how far it was going to go," said Casper.

Before the fire started, the Globe Hotel had looked innocuous enough to the nonprofessional eye. It was a brown three-story structure at the corner

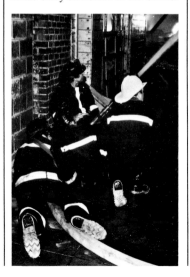

Division Chief George Berthold helps the men of Five Engine with a master stream in Brush Place.

of Folsom and Hallam Streets in the industrial South of Market area, right in the heart of a zone residents jocularly refer to as the Gay Belt. Ironically, the hotel had been built as housing for the men who rebuilt San Francisco following the '06 Earthquake and Fire.

During the mid-1970s, it became The Barracks, a gay men's bathhouse. In 1978, the place burned during renovation and had stood empty since. Now its owners were refurbishing with the aim of turning The Barracks into a residence hotel. Many new businesses, both gay and straight, were opening in the Gay Belt, and a form of gentrification was taking place. Low-income tenants, unable to keep up with soaring rents, were being replaced by a tonier clientele. The new Globe Hotel was intended to play to that market.

In the wee hours of July 10, 1981, the hotel was still a few

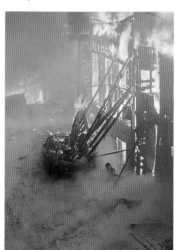

Right: The inferno in Brush Place. Opposite: Flames leap out of control on both sides of Hallam Street.

months away from its new beginning. The interior was stripped of all plaster and sheetrock; what remained was a wood-frame building with its wooden interior. No sprinkler system had yet been installed. The Globe, at this stage of construction, was "a bonfire waiting to start," according to Deputy Chief Condon.

"A big box of kindling is what you had. The most dangerous time for any building is during construction or renovation or demolition." The Barracks/Globe building was to become the seed of the most devastating San Francisco fire since the '06 conflagration—itself the largest fire in US history.

All it took was one angry arsonist, a workman who felt he had a beef with the owners of the hotel. Sometime after midnight, probably about 1:30, he set the fire at the rear of the building. It went unnoticed for 45 minutes, despite Folsom's lively nocturnal foot traffic. Once the fire had gotten a foothold, it spread explosively. The flames sliced up through the floors and out the roof. When the hotel collapsed, its outer wall fell across Hallam Street, clobbering half a dozen cars parked there. After smoldering a few moments, the building across the alley caught on with a great, crackling *whoof!* By the time firefighters had things under control, the Folsom Street Fire had destroyed or seriously damaged 27 buildings, left 127 people homeless, interrupted ten businesses, incinerated 30 automobiles. Estimated loss: $6 million. The one bright note was that somehow no one

was killed.

Hallam Street was a big-city industrial/residential dead-end alley in every sense of the word. It ran half a block off Folsom Street between Seventh and Eighth Streets, smack into the back wall of a large warehouse used as an indoor parking lot for delivery trucks. The back door of the warehouse opened onto Hallam—a fact that the firefighters discovered shortly after arriving. Thirteen Engine was driven through the building and parked near the big metal back door. The object was to swing the door open and lay a barrage of water directly into the face of the fire from ground level.

"We opened that door," recalls Patrick Pittson, driver of 13 Engine, "and great fireballs were coming down the street right at us. There were big plexiglass windows in the ceiling, and we could see the flames rolling back over the top of the building, over our heads. That was interesting to see."

Pittson means *interesting*. A schoolteacher for five years before becoming a firefighter, he is utterly matter-of-fact as he discusses his work. He and another 13 Engine crewman had aimed a big line out the door, straight into an impenetrable wall of fire that was advancing toward them at five feet per minute, shooting out lateral tongues of flame. Another smaller hose was playing a steady fog of water on Pittson and his workmate so they would not catch on fire. Nevertheless it was becoming

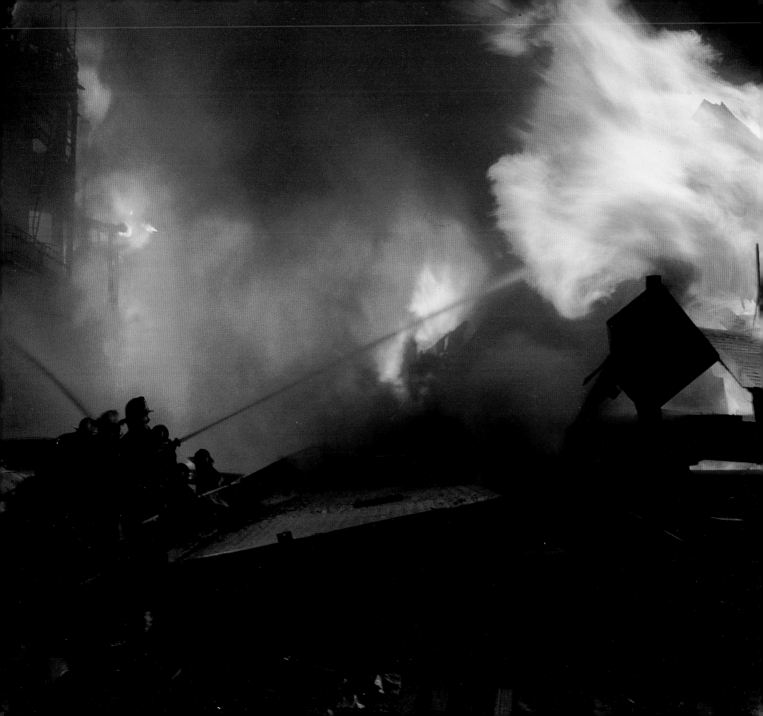

progressively hotter as the flames edged toward them. Pittson saw steam and smoke rising off his flame-retardant coat. "The steam you expect," he said, "but the smoke means your turnout coat is starting to smolder." He heard a frizzling, "crispy" sound in his ears; tiny hairs were burning away. Tilting his head, he could feel melted ear wax sloshing around like water. This put the temperature, he estimated, at about 175 degrees. A few degrees more and his ears and nose would blister, then catch fire.

Firefighters on a roof immediately west of the Globe, shortly before being forced to abandon the position.

For most mortals, such an experience would be absolutely petrifying. Long before their ear wax started dripping, most non-professionals would cut and run for a cooler, safer spot. And yet, to hear Pittson tell it, he'd rather fry than quit. We asked Pittson at what point his survival instincts would override his discipline and sense of duty: when would he know that it was time to let his feet do their stuff?

Pittson was surprised by the question. "Never," he said without missing a beat. "I move when my captain says move."

After five minutes of this trial by fire, his captain decided it was a losing cause and ordered the steel door shut again. Otherwise the fire threatened to sweep right inside the massive warehouse. Pittson and the rest of 13 Engine's crew remained inside, spraying water up at the warehouse ceiling so the metal and plexiglass roof wouldn't ignite. "Another interesting thing," Pittson added, "was that the door, after we shut it, was turning all sorts of reds and oranges as the flames played on the other side."

After a while, 13 Engine's company left the building and climbed up to the warehouse roof to send down torrents of water onto the flames surging along Brush Place, a dead-end side alley off Hallam.

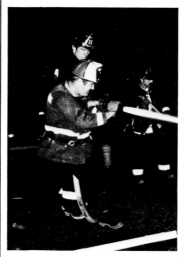

Ken Waggoner, a publicist for television station KQED, was working late that night in his apartment on Langton Street, a tidy little alley just one row of dwellings away from Hallam. He heard sirens, but there's nothing unusual about sirens in his neighborhood. Then there were more and more of them, and they sounded close by. Waggoner went up onto the roof and saw the Globe Hotel in flames. He saw Ron Barney on his aerial perch over the fire, screaming at the flames. The sky was orange, smoke was everywhere, firefighters were frantically bustling around, and there was a loud, continuous roar.

"One house just burst into flames all of a sudden. You know, sometimes you throw a crumpled piece of paper into the fireplace, it smolders for a second and *poof*, flames. This house went up like that. Within five minutes I could see its skeleton; I could see right *through* it. That's when I confronted the question. I thought, 'Be smart; accept the possibility that you may get personally involved in this thing; get yourself beyond the *why* of it, *now*, and *do* something.' I had to tell myself that, because the whole thing was paralyzing. I figured I had maybe a half hour to do whatever I was going to do."

In moments, Waggoner began grabbing possessions from his apartment to stash in his car for safekeeping. The homes on Langton survived the Folsom Street Fire, thanks to a desperate back-porch battle by the firefighters, although at one grim point the flames were only five feet away.

"I'm still shocked by it," Waggoner said a few weeks after the fire. "So are a lot of people around here. I didn't even lose anything, yet I feel a sense of loss over the disruption of my life. There's this feeling the fire had some weight, some meaning. I was impressed by the sheer energy, the stupendous power of it. It's probably the biggest single source of energy I've ever been around. The energy of it was the sort of thing you feel from the hills of San Francisco, from being in the mountains. The scale and majesty of the moun-

tains when you're there, you know. This fire was like that—a whole different dimension.

"I guess there's this fascination with the way fire works, with fire as a symbol of purification. Well, in this case, it was just nasty and depressing and totally gross. The smell alone was evil, awful. So this experience definitely made me sort out my feelings about fire and the direction of my life. I haven't finished with that yet."

The end of Brush Place is defined by the two-story red brick rear wall of a building owned by industrial psychologist Donald Livingston. He had just returned home from a business trip and had been up late, reading, unaware of any fire until he heard the sirens. Glancing out the window, he saw a flickering orange glow. "My first move was to run to the back window overlooking Brush Place. It was like something out of *Gone With The Wind*, except there was no sign of Clark Gable and Vivien Leigh."

What he saw instead was Brush Place rapidly filling with his neighbors. Moments after the Globe had collapsed, they had begun filing into the narrow alley, many still rubbing sleep from their eyes. They could not escape to Folsom Street; the way was blocked by the Globe's rubble and the advancing flames. They appeared to be trapped, and it was getting hotter and hotter. They were driven down the alley toward Livingston's building by the heat and by natural fear.

Livingston dashed downstairs to open his back door, providing a way out for the terrified survivors. Many were in shock, nearly immobilized by fear. Most were still clad in robes and pajamas. For Livingston, they exemplified the melting-pot character of San Francisco: old, young, parents, grandparents, children, couples, singles, straight, gay, all ethnic derivations. What they had in common was their neighborhood, now going up in smoke.

Many spent the night in Livingston's basement, attended to by the Red Cross, while firefighters ran hoselines through the back door onto Brush to hold back the flames. "One Spanish gentleman," remembers Livingston, "was completely disoriented. He sat and smiled like Buddha through the whole thing. One black woman, about 78, couldn't remember the name of her husband or any of her daughters. And I knew what they were feeling, because I was feeling it too. For approximately three hours I was sure this place was going to go. The heat was awful—it broke all of our rear windows—and the sparks and cinders were flying, landing on the roof.

"You're in . . . not exactly a panic, but you know there's absolutely nothing you can do. You have no control over the situation whatsoever. Had the wind been a little different and if I hadn't gotten back home that night, there's no way this block could have been saved. Because I had to tell the firemen they could go through this building; it wouldn't have been obvious from the street that they could get through."

At one point, Chief Casper was warned about a sado-masochist "slave quarters" in one of the buildings on Brush. Indeed, the next morning's *Chronicle* ran a large photo of such a room, filled with s/m paraphernalia, captioned: "Whips and chains and leather harnesses filled one corner of a room in a burned-out apartment." Based on the report of the tipster, the Fire Department had made an extensive search to be certain that no "slave" had been burned to death while strapped into bed and unable to get free.

Livingston and others were dismayed at the attention the national news media lavished on this aspect of the disaster. It had, they felt, put a "Sodom and Gomorrah" rap on what had been a quiet little multi-ethnic neighborhood, and they blamed Chief Casper for this brouhaha.

Later the Chief acknowledged that he understood their complaint. But he felt there wasn't much he could have done to change matters. Reporters had overheard the tipster's erroneous "news"—warning that somebody was possibly being fried alive—at the same moment Casper heard it. They asked him what he was going to do about it, and Casper replied that his men would make every effort to save lives. In the editing that followed, the reporters' questions were dropped, leaving the white-coated Chief alone on the air, talking about "slave quarters."

The newspaper photos the next day confirmed the existence of slave quarters in the fire zone.

Above: Men of Stations Six and Seven are silhouetted by a wall of flame in Brush Place. Lower left: Fire all but ignores the big lines of Five Engine and Rescue One in Brush Place. Lower right: Wetting down the day after. Opposite: Day-after aerial view of the holocaust, courtesy of KRON-TV's Telecopter Four. Folsom Street is in the lower foreground; Hallam Street runs perpendicular in the center of the picture.

And certainly the Fire Department had a responsibility to probe the rubble for evidence of human remains. The net result was that Casper wound up with undeserved egg on his face—an unfortunate side effect, since few fire chiefs could boast his knack for even-handed dealings with the media and the public.

A Folsom Street Relief Fund was quickly established to get clothes, shelter, and emotional care for the homeless. Psychiatric social workers were installed in a nearby building. Free clothing and other services were made available. Surprisingly, not many showed up to take advantage of them.

"When you've lost everything," said Livingston, who'd helped organize the fund, "you're operating from a total lack of reality. It can take weeks, months, even years to really deal with the emotional part of it. Many of the homeless were so freaked out by the experience that they just got themselves out of the neighborhood. We never saw them again. Their solution was to escape."

By 9:00 pm on July 10, a dozen hours after the fire had finally been brought under control, the San Francisco Arson Task Force announced the arrest of a suspect. At his preliminary hearing, it developed that Otis J. Bloom Jr. had confessed to his father that he had set the fire. His father turned him in to the police. Eight months later, the 38-year-old unemployed house painter was convicted of arson and sentenced to seven years in prison.

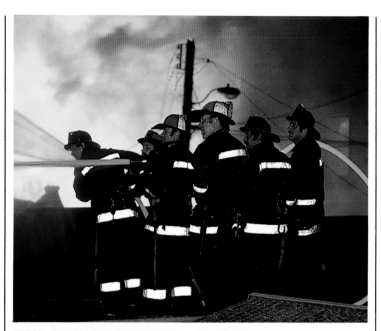

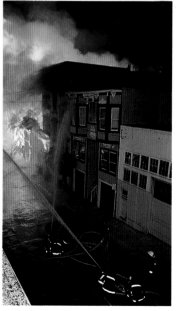

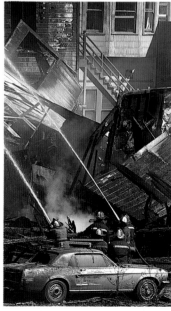

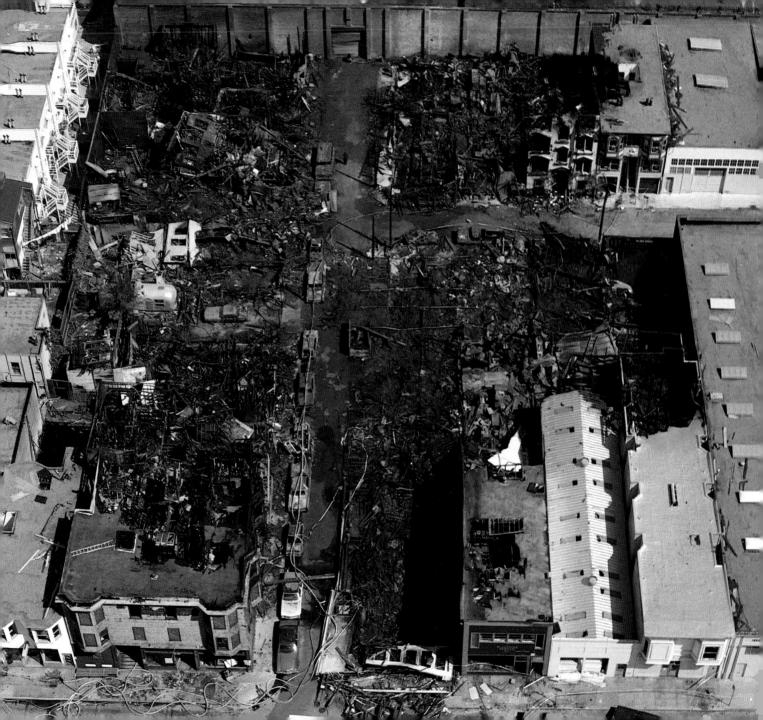

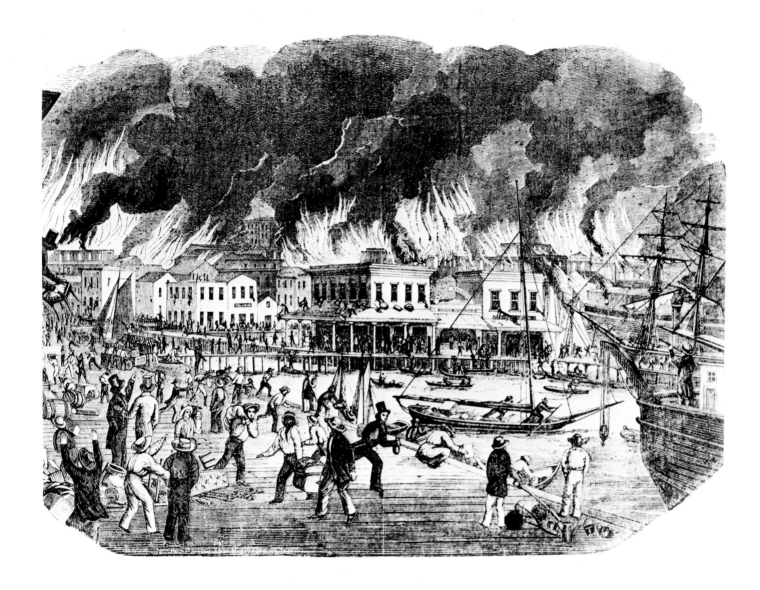

JUST WAITING TO BURN

From the start, San Francisco was an arsonist's dream, a fireman's nightmare

The first San Francisco fire companies were formed in the mid-nineteenth century in response to the growing number of fires that had burst forth during the early years of the city's astonishing growth. Composed of community-minded, relatively well-to-do (and some very wealthy) volunteers, the first fire companies brought personal firefighting gear to battle the blazes. Both their equipment and their savvy varied widely. And they were up against losing odds, for San Francisco was a city just waiting to burn, increasingly a magnet for thugs who regularly used arson to accomplish their ends.

San Francisco was a city planner's—and fire chief's—nightmare, tossed together in the fast-buck spirit of the Gold Rush. With the announcement of gold at Sutter's Mill, the population leapt from 500 to 6000, and then, during a four-month period in 1849, jumped to 30,000. It was a shanty town, its flimsy wooden structures jammed tightly together, swept by brisk winds capable of whipping fires into frenzies and driving them up and down the steep hills unimpeded.

"Gangs swaggered through the streets and taverns of San Francisco," wrote historian Tom Cole, "demanding protection money from cowed shopkeepers, taking advantage of what Josiah Royce called a 'destructive general license [for] mischief makers.' The Sydney Ducks, [a gang of former Australian convicts] very active in the protection racket, were popularly credited with setting at least some of the six major fires that burned through San Francisco with regularity from 1849 to 1851 . . .

"The Sydney Ducks and their ilk were not shy in threatening to take advantage of the tinderbox state of affairs. If a merchant fell behind in his protection payments, it was a simple matter to put his shop to the torch. If a few—or a few hundred—other buildings burned along with it, the Sydney Ducks and their fellow arsonists didn't much care."

Until a vigilante committee led by Sam Brannan struck terror into the hearts of the arson boys in 1851, more than 3000 buildings were destroyed in what came to be known as the "Six Fires." These deadly blazes might have spelled the death of another city, but San Francisco, throbbing with gold fever, rebuilt and rebuilt again. This never-say-die tradition is celebrated on the official seal of San Francisco, emblazoned with a gold miner, the mariner who brought him here, schooners on the Bay, and, above all, the Phoenix rising from the ashes of those early fires.

True to the flamboyant times, the early firefighters were a proud, even vain lot. Companies were fiercely competitive—as much over who had the snazziest uniforms and shiniest engines on parade days as to who got to the fires first and performed most nobly. Each company paid its own way, raising money for everything: station houses, equipment, uniforms, tools. To accomplish this, they staged glee club concerts, dances, fistfights. Many firehouses were homes away from home, with social quarters, libraries, and kitch-

Mid-nineteenth-century etching depicting one of the Six Fires.

ens capable of producing lavish spreads.

Citizens regarded companies the way fans today relate to their favorite teams, lining the streets to root for their favorites, gustily applauding acts of daring. This heady atmosphere proved an irresistible attraction to a San Francisco teenager named Lillie Hitchcock. In 1851, the young socialite began chasing fires with Volunteer Company Five, the "Knickerbockers." She would later become a fixture in very proper San Francisco social circles, the wife of financier Howard Coit, but she never lost her enthusiasm for the Knickerbockers. Nor did they lose theirs for her: she was appointed a lifetime member of the company and given a diamond-studded gold badge, which, historians record, she wore while attending the grandest social functions.

When she died in 1929, the heiress, who often signed her name Lillie Hitchcock Coit Knickerbocker, left a bequest enabling the construction of a monument in the shape of a fire

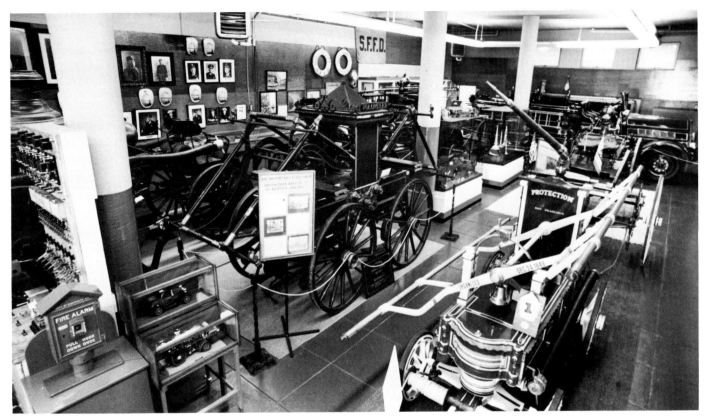

nozzle honoring her beloved firemen. Coit Tower today stands like a lighthouse atop Telegraph Hill.

Competition among the companies reached a state of madness during the 1860s. Companies accused each other of setting fires so as to be first on the scene to extinguish them. There were furious charges of sabotage and other chicanery. There were ugly threats. Finally, on a December day in 1865, a bloody street war was waged. It was the Monumental Six and So-

cial Three companies vs. the Knickerbocker Five unit; they fought with fire tools, knives, cobblestones, even firearms—a fittingly crazy and violent conclusion to the volunteer days. The citizens of San Francisco, alarmed and disgusted, soon gave the nod to legislation creating a new, salaried San Francisco Fire Department in 1866.

Intradepartmental competitiveness remained high, however. Companies to this day are highly competitive about who gets the job done. When two companies

arrive at a fire at about the same time, it becomes a point of honor not to be the first to back down. Firefighters have come close to fisticuffs when one company enters a burning building to relieve another, according to one veteran. "One company will say, 'You guys go ahead and back out; Chief says to relieve you.' And the other company will say, 'Hey, the hell with you and the hell with the chief—we're not leaving. We got a great lead going, and you're not going to come in and take credit!'"

The fascinating SFFD Fire Museum occupies quarters adjacent to Station Ten at Pine and Presidio. It is open to the public.

1906: The Enormous Firestorm

In the early dawn on the morning of April 18, 1906, most of San Francisco's 450,000 inhabitants awoke with a terrifying jolt. For nearly a minute, the city rocked and pitched. There had been earthquakes in San Francisco before, but never one like this. Seismologists later estimated it at 8.25 on the Richter scale. Above the deep, menacing rumble of the seismic dislocation one could hear windows shattering, buildings creaking and splintering, dishes crashing from shelves, screams. Four big aftershocks followed, leaving deep ruptures in streets, many wooden structures on tilt, and several brick buildings collapsed. One of the first civic monuments to crumble was the new, $8 million (and theoretically quakeproof) City Hall, recently completed after 29 years of construction.

Among those mortally injured in the early shocks was Fire Chief Dennis T. Sullivan, who had prophetically warned city fathers of the fire devastation that would almost certainly accompany a major earthquake. Indeed, six months before the big shake, the National Board of Fire Safety had sent a committee to investigate San Francisco, and their report (ignored by City Hall officials) laid it on the line: "San Francisco has violated all underwriting traditions and precedents by not burning up.... That it has not done so is largely due to the vigilance of the Fire Department, which cannot be relied upon indefinitely to stave off the inevitable." For this city of steep hills and high winds, with more than 90 percent of its buildings made of wood, the inevitable moment had arrived.

San Franciscans picked themselves up and piled out into the streets to see what the quake had wrought. The initial destruction was bad enough. But as the dust settled, an even more ominous portent presented itself: dense clouds of smoke were rising from innumerable fires all over town. The great shake had knocked over lanterns and candles and stoves, setting fires everywhere, and broken gas mains provided further fuel for the conflagration. The Fire would prove four times more destructive than the earthquake itself.

By the time the flames died out, three-quarters of the city's buildings were gone. Destruction was almost total in the downtown business section. It had been a firestorm of such enormity and intensity (reaching temperatures up to 2700 degrees Fahrenheit) that water was powerless to stop it. Not that there was enough water available from most hydrants to combat even a routine house fire; water mains leading into the city had been broken in some 300 places, and service pipes leading to hydrants were broken at 23,000 points,

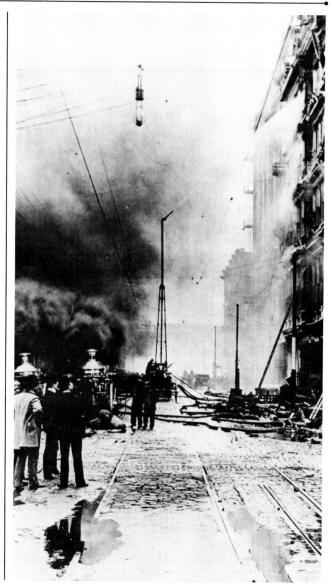

leaving water pressure at the merest trickle in most parts of town. Moreover, the SFFD had lost its communications when the quake wiped out its electric box-alarm and telegraph system. Fire companies had to improvise.

They battled the fire—with minimal success—for three straight days, joined by elements of the US Army. In some places, such as the western side of Van Ness Avenue, houses were dynamited away, creating an urban fire break to prevent the fire from marching all the way to the Pacific. In the end, a natural force intervened to spare what remained of the city. A west wind blew in from the ocean, pushing the fire back toward the burned-out heart of town, and finally it dwindled away.

A quarter million San Franciscans were left homeless. Tents were raised in the Presidio and Golden Gate Park to shelter survivors, as city officials and the business community set about making plans for the new San Francisco, soon to rise from the ashes and rubble of the ruined city. Many were amazed at the good nature and calm of the survivors. Wrote photographer Arnold Genthe, who so memorably captured the catastrophe of '06:

"The apparent indifference of the people who had lost everything was perhaps not so much a proof of the stoic philosophy that accepts whatever fate brings. I rather believe that the shock of the disaster had completely numbed our sensibilities. I know from my own experience that it was many weeks before I could feel sure that my mind reacted and functioned in a normal manner. If I had shown any sense, I might easily have saved some of the things I valued most—family papers, letters and photographs of my parents and brothers, books written by my closest relatives, and of course my more important negatives, which I could have carried away in a suitcase. As it was, nearly everything I possessed had gone up in smoke."

Statistics from the SFFD annals tell the rest: 315 killed outright, 6 shot for crime, 1 shot by mistake, 352 missing...28,000 buildings destroyed in a 4.1 square mile area...a loss of $350 million.

Left: April 19, 1906: steam pumpers and a Gorter water tower attempt to fight the flames on Ellis Street. Right: Arnold Genthe's photo view of the destruction of San Francisco: survivors in ever-proper attire view the downtown fires from Nob Hill.

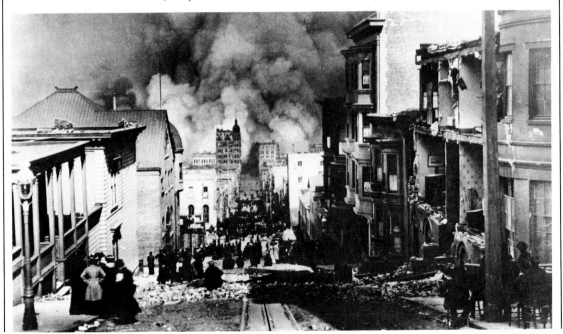

50 Years with the SFFD

"When you're doing something you love — and I love the Fire Department — well, that's probably the reason I remember so many things in detail"

Bill Murray remembers the '06 disaster as clearly as if it had happened the day before yesterday. He was six years old, and his dad was one of the 584 firemen who fought the fire. Murray grew up on first-hand stories of the city's biggest fire. In fact, one of his most prized toys was pressed into the battle.

Two days after the quake, he and his mother were ordered to depart San Francisco for the relative safety of Oakland, where his grandmother lived. Little Bill towed his toy fire truck all the way from his Telegraph Hill home to the waterfront where he and his mom were to catch a ferry for Oakland.

This was no ordinary toy fire truck. It had been built especially for him by the Graves Carriage House, which then built much of the SFFD's rolling stock, and it was a scale replica of the standard turn-of-the-century fire truck. "It was a terrific piece of equipment," recalled Murray three-quarters of a century later, "with running boards on the sides, coal lanterns, a brake — the kind where you step out and push down. The ladders, I can see in my mind, were blue, and the rig was the same dark red as the city trucks. It was big enough to sit on and ride, and the only trouble I had with it was to convince other kids to pull me around.

"One of the hazards of the rig was that it would turn very quickly, the way a truck would turn. So we used to roll over with the thing and crash. The kids would pull me down Grant Ave-

nue on it, to Lombard, and when you'd turn quick, over it would go. Fall off the damn rig.

"Anyhow, I had pulled that truck down to the waterfront that morning and we were waiting for the ferry to take us to Oakland, when two firemen came up — I can see them now, with those little peaked caps on 'em — one guy had an underwear shirt, no regular shirt, I'll never forget him — and they asked my mother: 'Could we take the little boy's truck? We need to move some mattresses.' My mother was tickled; she said, 'Why, sure!'

"Well, of course he was a fireman, and that was next to God so far as I was concerned. So I turned my rig over to him. I don't know to this day if it was pre-arranged. What I was going to do with that rig once we got to Oakland, I don't know. So when my mother got the opportunity, she said, 'Billy, give it to the gentlemen.' I gave up my rig and that was the end of it. Never saw it again to this day. I was heart-broken for a while, because, my God, it was a beautiful little set-up. But I was six and I have to admit it did make me a big shot — my truck and my dad fighting the big fire!"

Murray's father was a fireman from 1895 to 1934. William F. Murray Jr. signed on with the SFFD in 1920. "You know," he said, "most people go through this life and they do something they really don't want to. But from the day I was born, I was raised in the Department. In 1908, my mother sent me a card — have it in a scrapbook still — with a little

kid wearing a fire helmet, Nine Engine, and he's got a garden hose that's leaking and hitting him in the fanny with the water. And she wrote inside: 'Dear William, I hope you'll soon be able to report for duty.' She signed it: 'The Chief, SFFD,' put his name on it. I thought it was authentic."

Murray served with the SFFD for 50 years, the last 14 of them as Chief of the Department. "When you're doing something you love—and I love the Fire Department—well, that's probably the reason I remember so many things in detail."

He signed up as soon as he could, at a time when many of the new firefighters were veterans returning from World War I. Much of the department at that time consisted of men who had fought the Fire in 1906. "The new fellas coming in were a different breed, better travelled, better educated. Some of the old-timers that I remember had hardly gone through first grade, but they were rugged firemen.

"Lots of these fellas didn't know anything about driving something with a motor. Before I became a fireman, I had driven for Associated Oil and the Packard car dealership. But firemen didn't really own cars then. They'd have to run them through driving school to teach them how to drive the pumpers, trucks, big rigs. The fellas doing the driver training, they'd tell me: 'Bill, you won't believe this, but when we tell these fellas to stop, they yell *Whoa!*' They were still horsemen."

In 1920, the SFFD had almost converted to motorized rigs, but there were still two horse-drawn outfits, Six Engine and 33 Engine. "The horses," Murray said, "were quicker getting to a close box than the automotive apparatus. They used to encourage speed—hooking up the horses and getting out of the houses fast—by having contests. The fastest companies got to wear a silver Maltese cross.

"The times of those fellas getting out of the houses were phenomenal. They had what were called 'let-go' harnesses that dropped electrically from the ceiling. When the bell hit, the let-go dropped, the horses stepped right into the harnesses, the fellas snapped the collar, snapped on the lines and they were in business! The horses were out of there in a flash! If you look at the times they could make getting out the door, they'd almost make the firemen today look silly.

"Of course, the first five minutes was always the most important time to get on a fire. If you get a good bunch of fellas there in five minutes, you can do a helluva lot more to stop it. That still goes today. They beat that into our heads back then."

They still do. Today average response times in San Francisco are just over three minutes from the time the alarm is sounded—under three minutes in the downtown high-rise area.

Firehouses located atop steep streets, known as "hill companies," used block and tackle systems to move the heavy engines both downhill and back up again. One such was 31 Engine at Green and Leavenworth, a beautiful private residence today. In a brochure published by the St. Francis Hook & Ladder Society ("Vintage San Francisco Firehouses: Reminders of the Horse-Drawn Era"), Capt. Cornelius Green (SFFD Retired) told of employing block and tackle to lower

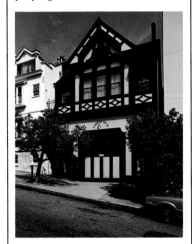

Above: One of the old "hill companies," 31 Engine at Leavenworth and Green, is today a wonderful private apartment and fire museum owned by Mrs. Ralph K. Davies. Below: Traditions die hard in the SFFD: flame-red apparatus, pressed leather helmets, and wooden ladders remain the norm.

the massive fire rigs down the steep cobblestone grade from Union to Filbert Street: "When it became necessary to fight a fire at the base of the grade, tackle was secured to the rear step of the engine and held taut, thus allowing the horses to keep their feet during the descent." On the ascent, the three engine horses were joined by the companion hose wagon's two animals to haul the weighty apparatus back to the top of the hill. Five horsepower was thus applied to bringing up first one rig and then the other, with the block and tackle being used for added leverage.

Murray worked with horse-drawn companies in his early years, but he was decidedly part of the new guard, moving quickly to the spot of driver on 21 Engine. Shortly thereafter he became a chief's operator, a combination driver and telegrapher from fire scenes.

Left: 10 Engine thunders along at full speed around the turn of the century. Right: The horses' last day of service at old 21 Engine, September 1915.

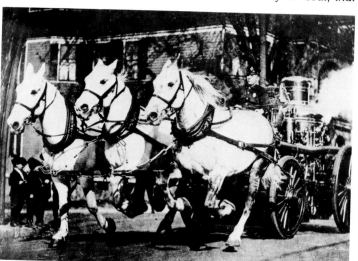

Discipline in those days was fearsome, the department thoroughly militarized. Officers could never be addressed by name. "If you didn't call an officer by his proper title, my God, that was a sacrilege," said Murray. "They'd file charges against you." And some of the officers could be exceedingly harsh.

"One day," Murray remembered, "a fella named Cy Wheeler, nice Southern fella, was told to wash the firehouse windows. It was a sunny summer's day; you ever try to wash windows in the hot sun? Sure enough, streaks on the windows. The officer says, 'Look at those streaks. Get back up there and do those windows again.' Still the streaks, of course. My God, the officer calls in the chief, and it winds up costing the poor guy 15 days' pay. I saw it all happen. Think you could get away with that today?

"A button on your coat, *that*

was a day's pay. Strict, strict discipline, let me tell you. If you smoked a cigarette outside quarters, and the chief caught you, God help you, brother. One fella down on One Engine where my dad worked was smoking out front one day; the chief came round the corner and what do you think he did? Swallowed it rather than get caught. And it was lit! Kind of ridiculous, but that's what it was like in those days.

"Ten every morning we stood inspection. We bought all our own clothes. We only made about $120 a month then, and a full uniform was about $65, as I recall. Vests and ties on for inspection and during the day. If you tore the seat out of your pants—it happened a lot on those shingle roofs, you'd go sliding down and hear a rip—you'd have to have a new pair by inspection next watch. At your own expense. Hard to believe we loved the job so much! Hell, somehow we managed."

The job was every bit as dangerous in those days, no doubt more so. "We didn't have breathing apparatus in my early days," said Murray, "just sponges covered with silk that we'd tie over our faces. Kept them up on the side of the helmet, and actually they worked real good. We probably had just as much chemical danger then. Folks used cyanide for fumigation, and if you got into a fire with that around, look out! Nitrocellulose in furniture, very combustible, explosive. My dad was blown out of a second-story win-

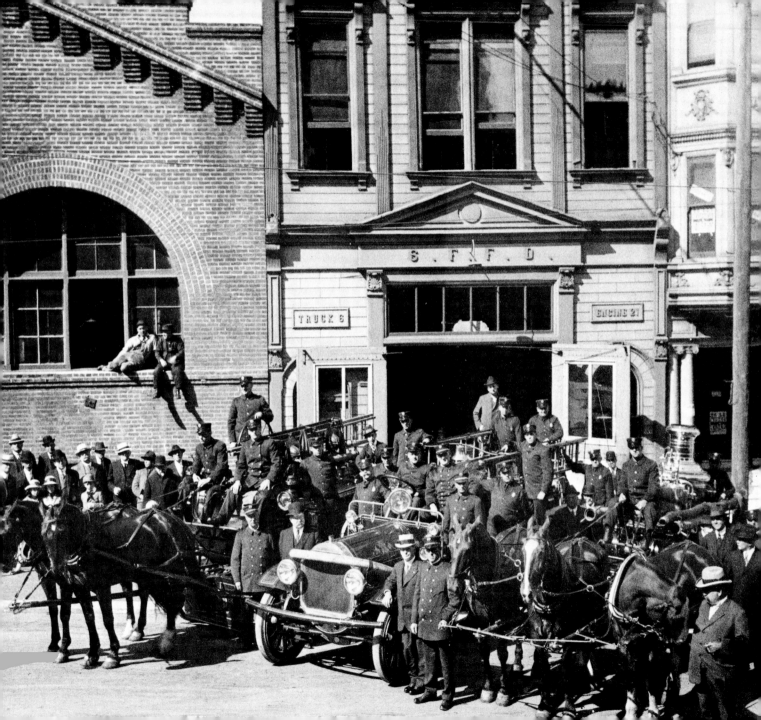

dow before the anti-fume ordinances were passed. There was all kinds of awful stuff stored around town, and very little understanding of how it would behave in a fire."

By the start of World War II, Murray was a captain, and on Pearl Harbor Day he was riding as an acting battalion chief. He was dispatched to Yerba Buena Island to pitch in on the war effort and worked 15 days straight before getting a day off. He was then picked as training chief of the Civil Defense fire service, and he set about instructing 10,000 volunteers.

By the time Murray was through with them, 5680 were completely trained. It was a force much larger than the SFFD, occupying 52 special firehouses and equipped mainly with hundreds of 600-gallon Chrysler trailer pumpers. Yellow Cab would send its taxis, all fitted with hitches, to tow the pumps around town in drills. Fortunately, they were never needed to combat war-related fire.

"When I became a battalion chief," said Murray, "I used some of these fellas to great advantage. They were awfully hot to fight some big fires, so sometimes I'd let 'em go in. All I could say was 'Don't get hurt.' They were a great bunch, but I'm certainly just as happy that the war never presented them with fires to fight. They'd have performed fine, but who needs it?"

By all accounts, Chief Murray exercised great generalship at fire scenes. He combined a well-conditioned instinct for where and how to attack with an equally acute sense of when to use restraint. "I always figured," he acknowledged, "that it was just as well to say, 'Let's back the hell out of here,' when the place was roaring unless there were lives to be saved."

A case in point was a huge fire at 29th and Mission to which Murray responded as an acting battalion chief. The place was an old car barn that had been converted into a bowling alley, and he had led some two dozen men with hose leads into position on the main floor. "It was pretty smoky, and small fires were popping up all around that we'd knock down. But pretty soon, two-by-fours were falling from above, here and there, and I hollered to the men: 'We're not doing any good—get yourselves under that mezzanine over there!'

"No sooner did I say that—I'm still standing out in the middle of the floor—than the whole joint came falling in. One big 12-by-12 went crashing right through the mezzanine balcony—didn't hit one guy—and I remember saying to myself—this is God's honest fact—'Murray, this is your last day on earth.' I ran like hell to get under that balcony. It was a sea of fire. We'd all have gotten it good if we hadn't ducked underneath.

"So how did I know to do that? To get everyone out of the way? Well I guess you smell it. You get a hunch; you hear certain sounds. Old Chief Sullivan came up to me after—newspapermen all around—and wanted to know if I was sure all the men were out of there. I told him I'd called the

Members of the Veteran Fireman Association roll out the old Knickerbocker pumper in the late '30s. The quarters of 49 Engine on 18th Avenue (the home of 40 Engine today) were then used to store old-time firefighting apparatus and memorabilia.

roll and all the men were accounted for. Then he said: 'Bill, how'd you know to get those fellas out of there?' I said, 'Chief, I guess I know when I'm getting beat. We weren't doing any good; those timbers were coming down; things just didn't look so good.'"

That satisfied Chief Sullivan. Courage is routinely expected of firefighters, and so is good judgment.

Murray's feeling was that this sort of judgment, although it will always have to come along as a by-product of experience, can be developed via a thorough training program. "I look back on the days when I started—just a boy, really. I got involved in a fourth alarm around Sutter and Franklin, on maybe my third watch in the department. I hadn't had any training, I had no idea of what was going on, not a speck of judgment. That's what drove me to put together a training program when I became Chief. That's why our training program is so demanding. Here they just graduated another class from the fire college; I don't know what number that is now. Well, I started the first one.

"Training is all-important, because if you and I are working together, we have may have our differences, but we both have to know that when the chips are down all that will disappear and we'll both know how to do our jobs. Because you might be the guy I'm depending on to pull me out of some spot. And vice versa. So, my God, we'd better both know our stuff."

Tank Wagon Seven, a 1937 Fageol, has been lovingly restored by collector Richard Stacks.

THE BASICS

"Putting the blue stuff on the red stuff"

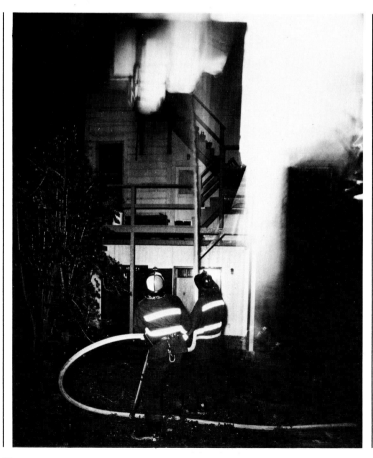

The physics of fire come back to us from junior high science class. Fire requires three things to perpetuate itself: combustible material, oxygen and sufficient heat to initiate the oxidization process. When wood—the material used in the construction of 96 percent of San Francisco's structures—reaches a temperature of about 400 degrees, it begins to interact with the oxygen in the air around it. The wood vaporizes, giving off greyish-brown fumes, better known as smoke. The rate of oxidization increases as the temperature goes up, leading to combustion: visible flames appear at the points of vaporization. This process, if left alone, will continue until all but the most heat-resistant part of wood—the ash—has gone up in smoke. The fire then burns itself out.

It is this process the firefighters seek to interrupt, and they do so primarily by laying on water— "putting the blue stuff on the red stuff." From the days of fires flickering in Neanderthal caves, man has used water to douse the flames; to this day there's hardly

Pre-dawn fourth alarm destroys two wood-frame apartments in the Western Addition.

anything that does the job better. No other substance on the planet requires so much heat energy to raise its temperature one degree. Even steam, its temperature hovering around 212 degrees, is cooler than the flash points of most combustible materials. Water takes the heat out of the fire and separates it from the oxygen it craves.

To the SFFD there's almost no such thing as too much water when a serious blaze has erupted. Each San Francisco pumper can throw out up to 1500 gallons per minute through several hoses and nozzles simultaneously; small incidents will usually succumb to a few bursts from a single small line, but huge blazes like the Folsom Street holocaust seem almost to ignore a battering that might ultimately total millions of gallons from a hundred leads.

Lack of water was the overwhelming problem for firefighters during the '06 Fire. The quake had utterly smashed the city's water lines. Engines near the waterfront were able to pump water out of the Bay, but inland the battle was unwinnable. That catastrophic water shortage led a resurgent San Francisco to install the nation's only triple-redundant firefighting water system. It consists of:

• Low-pressure hydrants carrying 40–60 pounds of water pressure. There are about 7000.

• Taller high-pressure hydrants, recognizable by their colored caps and fatter profile, fed by separate plumbing and putting out 160–300 pounds of pressure.

Optional water tanks on Twin Peaks and Russian Hill (referred to specifically as the Ashbury Tank, the Jones Street Tank, and the Twin Peaks Reservoir) can kick additional water and pressure into the system when needed. There are 1400-odd high-pressure hydrants.

• Two last-ditch pumping stations along the Bay shore capable of inundating either of the above systems with sea water in the event of another monumental disaster. The Bay pumping stations have never been called upon to inject salt water into the firefighting mains.

There are also 151 storage cisterns beneath many of the city's street intersections. These 75,000-gallon tanks are demarked by a circle of bricks in the pavement; they are frequently explained away by tourist daddies as old abandoned cable car turntables. The hard-suction line carried on every pumper can be low-

ered into the cistern, and the rig can then run at full output for almost an hour before draining one. The cisterns aren't used except in drills, but they stand waiting for the Worst Case. Cistern water levels are checked monthly.

San Francisco firefighters often advance directly into a burning building in search of both potential victims and "the seat of the fire," crouching behind the wide-angle spray of an Akron fog nozzle. This wonderful invention can put out a spray ninety degrees wide or a conventional pinpoint stream at the twist of a control tip. The wide spray forms a shield of droplets that sucks the heat from the fire and allows the firemen to close right in on the flames. When the battle for the building has been declared lost, firefighters will back away and resume the attack with long-range "master stream" nozzles that accurately drop in huge volumes of water.

Circle of bricks in an intersection demarks an underground storage cistern.

Ventilation: Chopping Holes and Smashing Windows

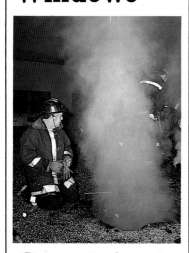

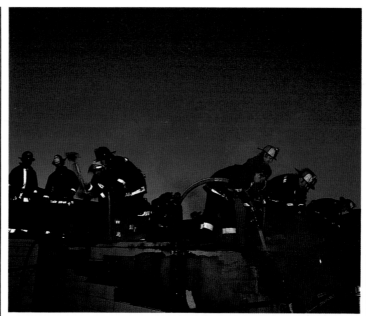

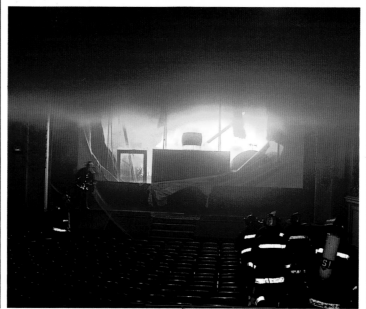

One question firemen hear constantly is this: Why the hell are you guys chopping holes in the roof and breaking out all those windows when the fire is way down on the first floor?

Spectators at fire scenes have no trouble understanding what the men on the hoselines are doing, but they're often bewildered by the sight of other firefighters chopping and smashing

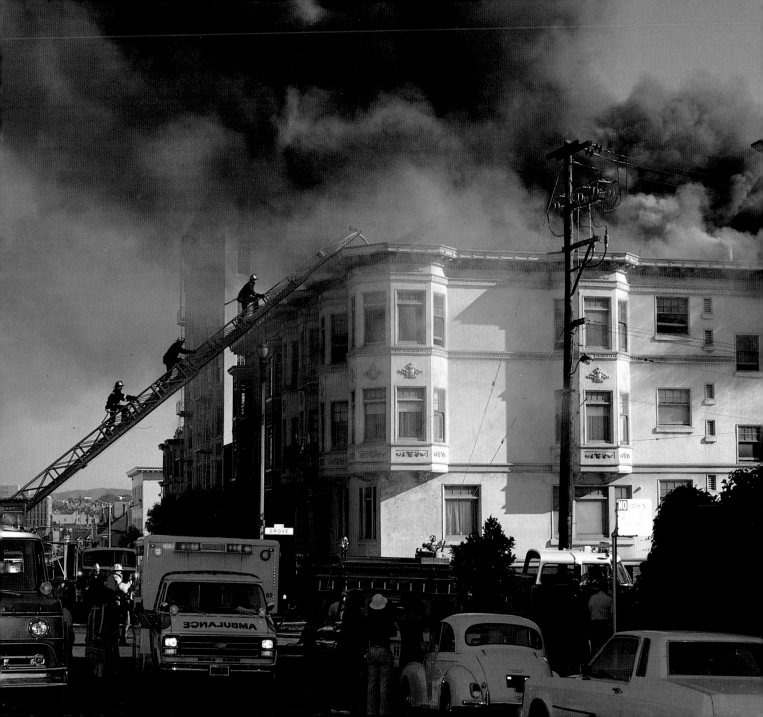

Above: Division Chief Ron McInnis pep-talks Rescue Two prior to a difficult search at a Polk Street fifth alarm. Below: Chief Murray with Capt. Andy Benton in the early '60s.

away with their axes. To the uninitiated it looks pointlessly destructive. The object is to ventilate the building—to provide an avenue for the smoke to get out, and to cool things down inside. Ventilation gives firefighters in the building cooler, more breathable air and better visibility. But even more importantly, it lessens the danger of one of the firefighters' gravest fears: the oxygen explosion, or backdraft.

"Once when I was Chief in the early '60s," remembered Chief Murray, "I was rolling toward a greater alarm in a four-story place on Valencia. They had just pulled a third alarm, and as I got out of the buggy, my God, the whole place shook. They hadn't yet gotten up onto the roof to cut any ventilation holes, and there were all these guys from Station Seven up on the third floor, doing rescue work, getting people out of there.

"It's so important that you open up that roof, see, because if you don't the heat builds up, mushrooms along the ceiling, and backs down worse than ever. Then the first opening you make to let oxygen in, *bang*, she'll blow."

Someone had said something about kids still being on an upper floor, so the captain of Seven Truck, a former Marine sergeant named Andy Benton, grabbed another truckman and headed upstairs—just as other firefighters were opening a rear fire escape window to get inside. The explosion blew out windows, shooting out tongues of flame in a dozen places. The fireman

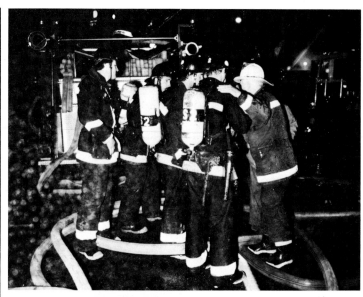

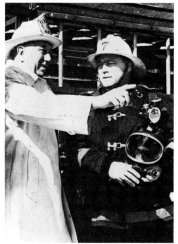

who'd accompanied Benton was knocked down a flight of stairs by the blast and was spared. "But it blew Benton the other way," said Murray, "and killed him. You should have seen his leather helmet. Just flattened his helmet. He never knew what hit him."

Firefighters have differing ideas about sensing backdrafts in time. Chief Casper remembered an old probationary officer warning him to be aware of a weird, high-pitched whistle that often preceded an oxygen explosion. To a veteran officer at Station One, the most frightening sound is no sound at all. "You're inside the joint," said Captain Dave Frisella, "and it's getting hotter than hell and it's *silent*. Now that's scary. No cheery sounds of people hacking holes in the roof, no breaking glass. The sound of crackling is reassuring; it means the fire is venting and air is coming in. The silence I'm talking about is a dead sound, as if your ears just quit working. That's my sure sign to back everybody the hell out."

A Team Effort

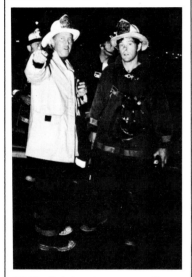

Firefighting is a team effort—different men doing different things at the same fire at the same time, all of them executing a drill as neatly choreographed and as carefully rehearsed as any 49er play at Candlestick Park. In fact, firemen frequently use team-sports analogies when they describe their work. Let's look at the first-alarm response to a typical Tenderloin six-story apartment fire to get an understanding of the different responsibilities.

A first-alarm "full box" assignment will put on the street three fire engines, two fire trucks, two chiefs and a rescue squad—32 men in eight vehicles converging from all directions.

Barring unusual circumstances, the first arriving engine will roll up just beyond the fire building, leaving room for the first truck to stop right in front and throw its aerial ladder. The first engine's driver becomes the pump operator and sets about leading a line from the engine to the building's ground-level standpipe inlet. The engine officer and two other members head into the building, carrying a hose bundle, nozzle, Y-connector, and pump-can extinguisher.

The second-arriving engine will *back* up to the first engine, drop a supply line along with its crew, then roll toward a rendezvous with the hydrant at the corner. One man from the second engine hooks a line into the first engine, while the driver/pump operator is busy hooking up to the hydrant. Water will soon be flowing from the second engine through the first and into the building's floor-by-floor stand-pipe system; by now the companies inside the building are hooking their hose lines up to the outlet on the fire floor.

Meanwhile the third-arriving engine has parked some distance from the scene, its crew reporting in front of the fire to provide manpower as needed.

The first truck will stop directly in front, and the driver will jump up onto the turntable to raise the powered 100-foot aerial ladder to the roof. Two truckmen will first pull out jacks on the inboard side of the truck to prevent the aerial from tipping the rig over. At the same time, two other crewmen will be throwing a 22-foot wooden ladder up to the building's fire escape. If an enormous blaze greets the first-due companies, with flames already breaking through the roof and making forced ventilation unnecessary, the aerial might first be fitted with its large ladder-pipe nozzle, and the tillerman—the guy who steers the truck from the back—will scurry up the ladder to handle the stream.

The second truck on the scene has a bit more flexibility. If the fire building is on a corner, the company will turn onto the perpendicular street and run up the aerial on that side. Otherwise the truck will probably be parked in front of the building next door, lest it too should catch fire, and its crew will report up front for orders.

The four-man crew of the rescue squad will show up front-and-center wearing their Scott Air-Paks, and they'll usually head right into the building to size up the fire situation and help with evacuation. "Squaddies" are elite inside firefighting experts, the shock troops in the firefight to follow. Both the officer and the driver of the squad are equipped with walkie-talkies, so they can report their findings to the chief, who by now has taken command on the street outside.

Two chiefs, in fact, have responded to the fire with their operator-aides. Usually a division chief and a battalion chief are due. The division chief will take charge of the fight from a vantage point in front of the fire building, while his operator stays

Chiefs are identifiable at fire scenes by their white helmets; the Chief of the Department traditionally wears a white coat as well. Here Chief Casper gives instructions for the inside firefight to Chief Mike Farrell.

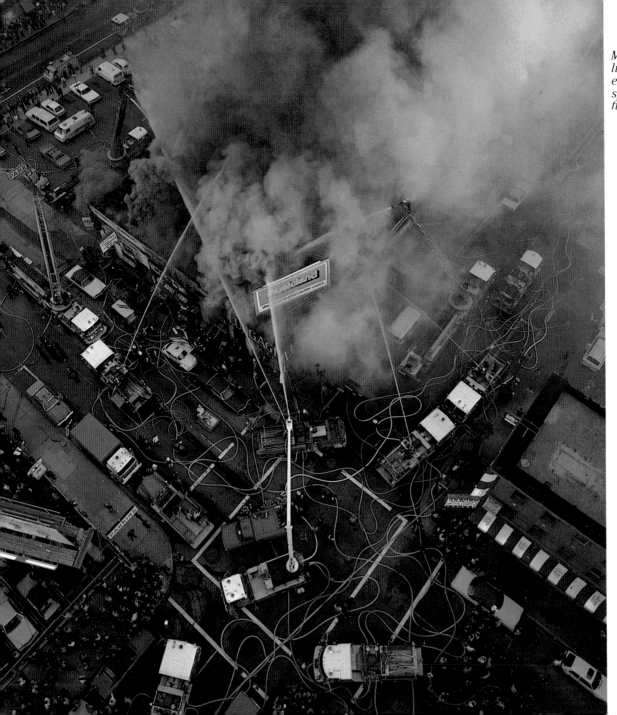

Miles of "spaghetti" link 40 pieces of equipment at a spectacular Tenderloin fifth alarm.

with the buggy (any SFFD automobile is, and probably always will be, a "buggy") to maintain communications with Radio. The BC and his aide both head inside to take charge of the close-in fighting; if fire is showing at several points, the chief might head for the side or rear while his operator goes in the front door. Both have walkie-talkies with which to report from their points of view.

One wonders how things were done before the invention of the now-ubiquitous walkie-talkie portable radios. Chief Ed Phipps recalled a tragic example of firefighting confusion from the days when shouted orders and message-carrying runners had to suffice.

"We got a box for a dump called the Thomas Hotel on Mission; this was around 1961. It didn't look that bad when we rolled up—fairly rough smoke and folks milling around in their p.j.'s. Well, we got into our Scotts and headed slowly up the stairs; we couldn't see anything, but we kept hearing this strange *thump* sound every few moments. We kept asking, What the hell is that noise? Another *thump*.

"Finally somebody looks up from a window in the rear, and it's going like holy hell on the top floors in the back. You couldn't see a thing from the Mission Street side; you had to look up the lightwell to see what's going on. The sound was people jumping into the lightwell, hitting the bottom; they'd thrown down a bunch of mattresses to soften the

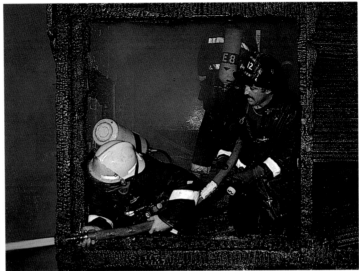

fall, but you can imagine how much good that was doing. The fire was forcing them out the windows. About 20 people died before we could communicate what was going on. We made a lot of good rescues that night, but I don't mind telling you I can still hear that *thump* sound plain as day."

The first-alarm drill unfolds automatically, with scarcely an order being given, even when it appears unlikely that there's much of a fire inside. "It's best to run through the motions every time," said one veteran truck officer, "and besides, we can all tell tales about interesting surprises that looked like nothing from the street."

There's another drill for downtown high-rises: first engine and truck crews plus battalion chief to the fire floor; second engine for lobby and elevator control; third engine and second truck to the floor above the fire for ventilation and evacuation; division chief running the show from the alarm panel in the lobby. Out in the Avenues, the first-alarm response is smaller—three engines, two or sometimes only one truck, just one chief and his operator, no rescue squad—and the drill places more emphasis on getting firefighters inside, since there is little likelihood of encountering standpipes or multi-story structures presenting tough laddering problems.

There are exceptions to these policies and a little room for initiative on the part of individual firefighters, but *only* a little. If fire is obviously rolling out of windows on the first engine's arrival, the company will usually elect to charge up the front stairs with a pre-connected 200-foot "ready line," or even with a three-inch

"big line" if things are really cooking. The engine company also has the option of running from their 500-gallon internal tank—good for about three minutes of water through the two ready lines, and that's time enough for their pump operator to get them safely onto hydrant water. Similarly, the second truck might see trapped tenants in rear windows and opt for ladder work in the alley instead of dutifully checking in front; in that case one man will be sent as a runner to tell the chief the gravity of the situation in back.

"I went to the Gartland Apartment Fire in 1975," recalled Don Frediani, "and that was a fire where all this drilling really paid off. That place just exploded into flames—some wacko arsonist set it off—and people were hanging out of every window, literally by their fingernails. Thirteen people died there, and I think there were some more they never found. In a situation like that, you can't let yourself worry about the whole mess—it's too horrible. You're the pump operator? All right, get the damn water out of the hydrant and into the rig—*that's* your job. The ladder guys are right behind you, and the squaddies, and *they'll* do the rescuing. Meanwhile the rest of your engine crew has gone roaring inside with a line, maybe running off the tank, and that water had better be there in two minutes or they're in deep trouble. You hit a fire like that without a plan, you all get inside making your own priorities as you go along, you're going to lose."

There is a firm chain of command at fire scenes, as befits a paramilitary organization. Each arriving officer can take charge until his superior officer shows up, at which time he defers. If the fire goes into greater alarms—second, third, fourth and fifth—overall command might be assumed by one of the two deputy chiefs—radio code CD-3 and CD-2—or by the Chief of the Department, CD-1 himself.

Chief Casper used to respond to practically every second alarm and take charge. Emmet Condon, the fire prevention specialist who became Chief when Casper retired in 1982, elects to respond only on the third alarm, although one of his deputies will often head for the fire when the second alarm goes on the air.

Any firefighter can get on the horn and yell for a second alarm; he'll never get called down for doing so, even if the request should turn out to have been unnecessary. The SFFD always prefers to err on the side of massive response.

It's a pretty serious fire that can't be handled by a full first-alarm assignment, so greater alarms are not common in San Francisco, usually numbering under one per week. The chart below details deployments for alarms one through five.

A second alarm also rolls the service squad for filling Scott air bottles, the arson investigation team, and mechanics from the Bureau of Equipment. A fourth or fifth alarm will usually be accompanied by "special calls" for attack hose tenders, the other rescue squad, the snorkel arm of Eight Truck, etc. Central Emergency will also dispatch a city ambulance on each of the second, third and fourth alarms, although their chronic short-handedness sometimes makes that impossible. In all, a general (fifth) alarm will put some 40 pieces of equipment and 150 firefighters at the scene.

The prospect of two simultaneous fifth alarms in San Francisco is an unnerving one. With practi-

ALARM	ENGINES	TRUCKS	CHIEFS	SQUADS
First	🚒🚒🚒	🚒🚒	◣◣	🚒
Second	🚒🚒🚒🚒	🚒	◣◣	
Third	🚒🚒🚒🚒	🚒🚒	◣	
Fourth	🚒🚒🚒🚒	🚒	◣	
Fifth	🚒🚒🚒🚒	🚒	◣	

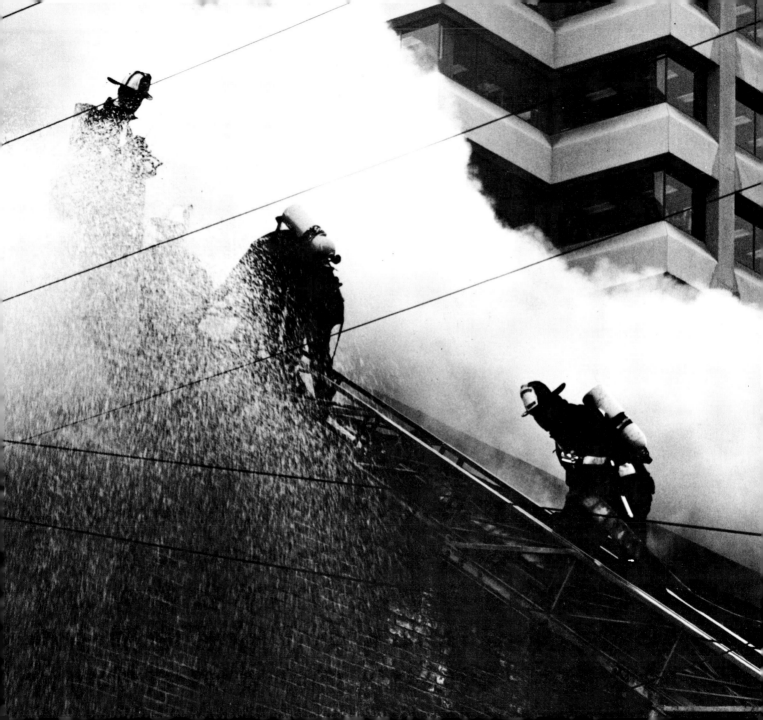

cally every company out of service, the SFFD would probably have to request mutual assistance from surrounding communities. Such a request has hardly ever been made, although it has been a close call in several recent instances: the Folsom Street Fire, the double fourth alarms on the same block of Waller Street in 1975, the enormous Kaplan's general alarm on Market Street in 1979, and the Thanksgiving 1980 nightmare when concurrent fourth and fifth alarms two miles apart stripped the city of all but a few engines and one truck.

Adherence to drills, rote and orders can be critically important, because individuals in a major firefight frequently have little or no idea of the big overall picture. Rescue One's Lt. Jimmy Lyons remembered a chilling example.

"We were inside at a greater alarm around Polk and Bush a couple of years ago," he recalled. "Four-story joint with pretty good fire on the top floor and up the center stairwell. We were kicking in doors on the second floor, making sure everybody had gotten out, when the word comes over the portable from Chief Condon to clear out. Now we were doing fine—no heat, not much smoke—so I say on the radio, 'No sweat, Chief, just let us finish up this floor,' and Rescue Two chimes in, 'Doin' fine here too, Chief; we got a real good lead going with Three Engine.'

"Condon comes back on the air, real forceful: 'Everybody out *right now.*' Orders are orders, of course, so we all troop out. I get on the street, turn around, and, Jesus Christ, the whole top half of the building is going from end to end. Going to fall in any minute, which it soon did. That place is a hole in the ground now. I've got pretty good instincts, but that one really took me by surprise."

The firefighting basics have changed little throughout history. Chief Murray's capsule summation: "You locate the seat of the fire, you surround it with charged hose lines, and you ventilate while you're knocking it down with water. Those aren't my rules; they're old as the hills."

It may sound simple, but it can take years of crawling down hot, smoky hallways before the firefighter can accurately size up the situation. Firefighting will always be more art and instinct than science, and it will undoubtedly remain the most dangerous profession in America.

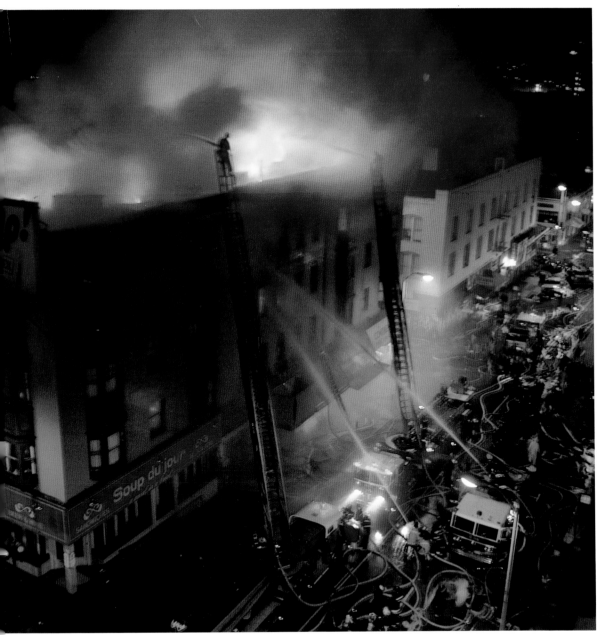

Fifth alarm at Sutter and Polk, November 1980: "I get on the street, turn around, and, Jesus Christ, the whole top half of the building is going from end to end."

TOOLS OF THE TRADE

The Cairns "New Yorker" pressed leather helmet, looking almost exactly like its counterpart of a century ago, is the preferred headgear of the SFFD. Federal safety experts frown on supposed safety shortcomings of the New Yorker; OSHA advocates various space-age plastic designs. But firefighters in San Francisco, New York, Chicago, and Boston stick doggedly with their traditional helmet; they tell tales of new plastic models softening in clouds of chemical smoke, and all firemen prefer leaving their ears in the clear to provide early warning of high temperatures.

This chief's New Yorker was his father's helmet a generation ago, and he expects to pass it along to his son. It has been repainted a dozen times in accordance with the SFFD's long-standing color code; red and white for truckmen, black for engine crews, white for chiefs, black and white for their operators, and blue for arson investigators.

The Scott Air-Pak gives a firefighter a half hour of cool, breatheable air in a 25-pound back tank. Heavy exertion will cause the air to be used up much faster, however, and a common sound in an inside firefight is the dinging of signal bells that warn the Scott wearer to get outside and change bottles within two minutes. The Scott and other self-contained breathing systems, along with the fog nozzle, have revolutionized inside fire attacks and searches.

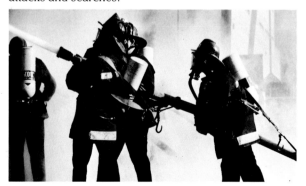

These firefighters, directing a big-line master stream into a burning chemical warehouse, are wearing their Scotts because of the added threat of toxic smoke.

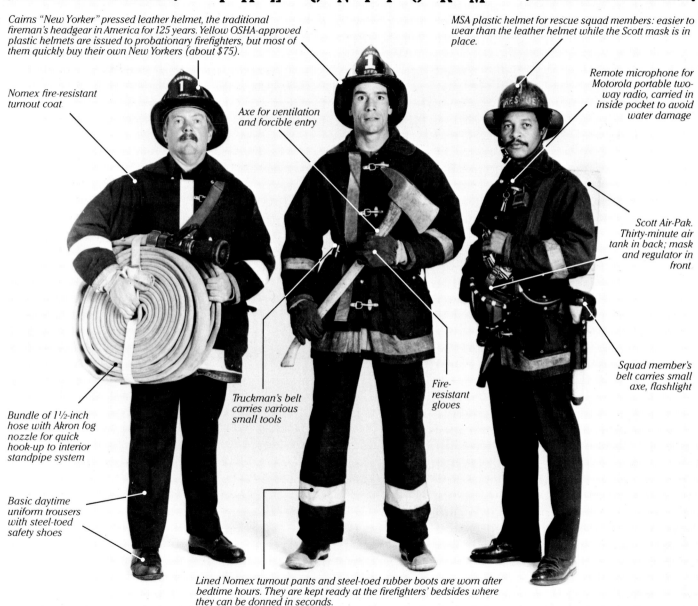

Cairns "New Yorker" pressed leather helmet, the traditional fireman's headgear in America for 125 years. Yellow OSHA-approved plastic helmets are issued to probationary firefighters, but most of them quickly buy their own New Yorkers (about $75).

MSA plastic helmet for rescue squad members: easier to wear than the leather helmet while the Scott mask is in place.

Nomex fire-resistant turnout coat

Axe for ventilation and forcible entry

Remote microphone for Motorola portable two-way radio, carried in inside pocket to avoid water damage

Scott Air-Pak. Thirty-minute air tank in back; mask and regulator in front

Fire-resistant gloves

Squad member's belt carries small axe, flashlight

Truckman's belt carries various small tools

Bundle of 1½-inch hose with Akron fog nozzle for quick hook-up to interior standpipe system

Basic daytime uniform trousers with steel-toed safety shoes

Lined Nomex turnout pants and steel-toed rubber boots are worn after bedtime hours. They are kept ready at the firefighters' bedsides where they can be donned in seconds.

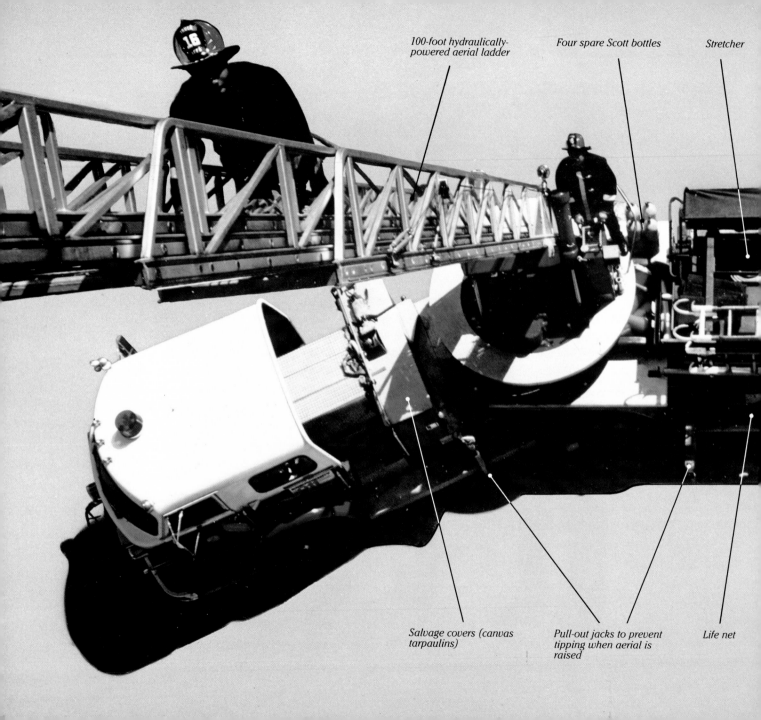

100-foot hydraulically-powered aerial ladder

Four spare Scott bottles

Stretcher

Salvage covers (canvas tarpaulins)

Pull-out jacks to prevent tipping when aerial is raised

Life net

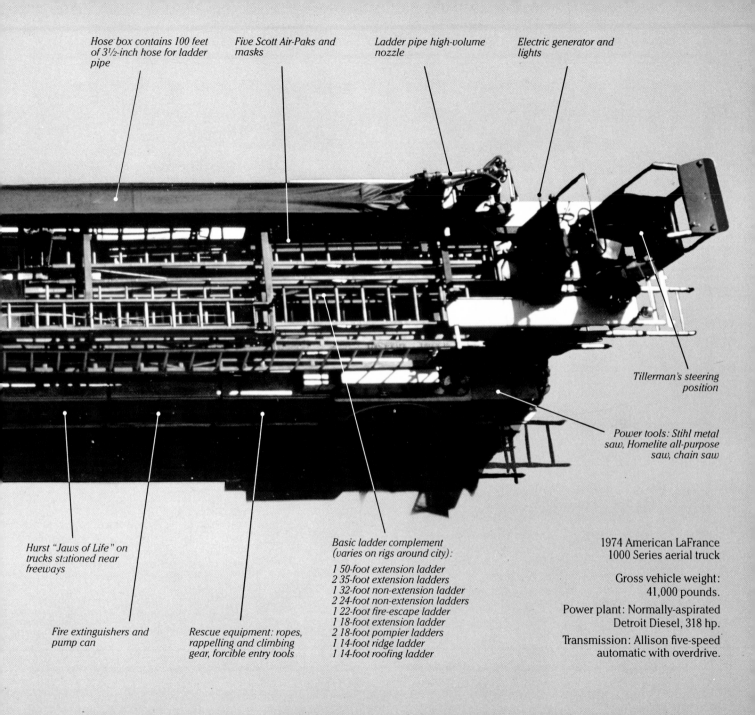

Hose box contains 100 feet of 3½-inch hose for ladder pipe

Five Scott Air-Paks and masks

Ladder pipe high-volume nozzle

Electric generator and lights

Tillerman's steering position

Power tools: Stihl metal saw, Homelite all-purpose saw, chain saw

Hurst "Jaws of Life" on trucks stationed near freeways

Fire extinguishers and pump can

Rescue equipment: ropes, rappelling and climbing gear, forcible entry tools

Basic ladder complement (varies on rigs around city):

1 50-foot extension ladder
2 35-foot extension ladders
1 32-foot non-extension ladder
2 24-foot non-extension ladders
1 22-foot fire-escape ladder
1 18-foot extension ladder
2 18-foot pompier ladders
1 14-foot ridge ladder
1 14-foot roofing ladder

1974 American LaFrance 1000 Series aerial truck

Gross vehicle weight: 41,000 pounds.

Power plant: Normally-aspirated Detroit Diesel, 318 hp.

Transmission: Allison five-speed automatic with overdrive.

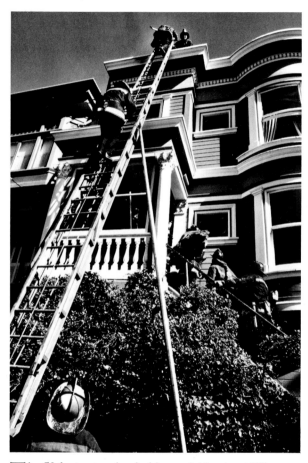

The SFFD's old-fashioned wooden ladders are hand-made and repaired by a pair of master woodworkers, Orval Taylor and Al Burke, at the city's central shop facility. The sides are soft douglas fir, for lightweight strength, and the rungs are made of hickory.

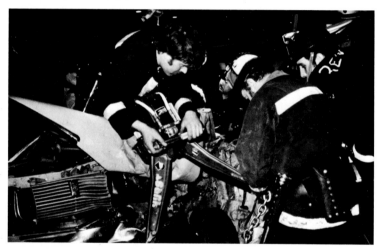

The 50-foot extension ladder, weighing in at 350 pounds, is the longest and heaviest of the truck's many wooden ladders. A crew of six is required to raise it safely. Two men hold outrigger poles to steady the ladder. Despite its great size and weight, it can be deployed very rapidly by a crew well-practiced in its use.

The Hurst Rescue Tool, known more commonly as the "Jaws of Life," is carried on both rescue squads and on trucks that are stationed near the freeways and bridges. Its gas-powered compressor generates 12,000 pounds of hydraulic force that can be directed into either of two hand-held tools—a cutting shears or a spreader. The Jaws of Life is employed principally to extricate victims from crushed automobiles; it can carve and pry its way into any wreck in minutes.

*L*adder pipes can direct huge volumes of water onto major blazes with great long-range accuracy. The nozzles and 100 feet of three-and-a-half-inch supply line are carried on all trucks. The truck's tillerman becomes the ladder pipe operator when the decision is made to put the master streams to work — usually at the unsuccessful conclusion of the inside firefight.

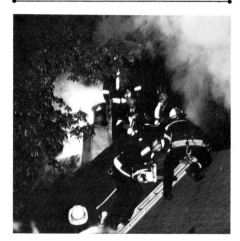

The truck carries a variety of power saws: a gasoline chain saw for cutting large ventilation holes, a Homelite all-purpose saw for ripping into burned-out interiors in search of hot spots, and a Stihl metal saw that can slice an opening in the heaviest steel doors.

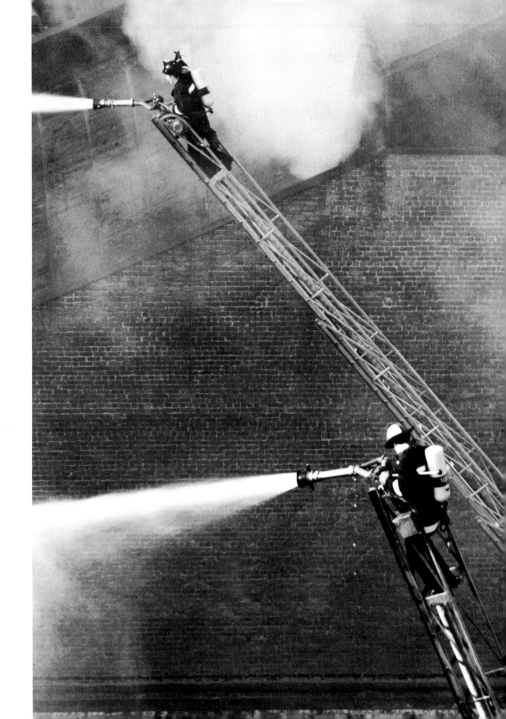

The driver of the engine operates the pump panel at the fire scene.

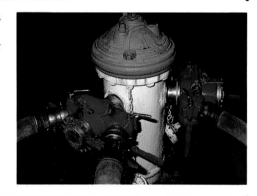

Hand-crafted brass Gleeson valves are used to control the pressure from high-pressure hydrants. The 93-pound valves are fitted to the hydrants at major blazes by the engine's pump operator.

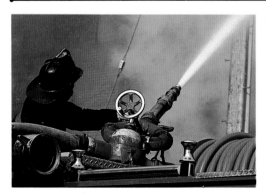

The engine's multiversal nozzle can throw out 800 gallons per minute in a precision master stream.

1977 American LaFrance
Century Series pumper

Gross vehicle weight: 25,000 pounds.

Power plant: Turbocharged Detroit Diesel, 305 hp.

Transmission: Allison four-speed automatic.

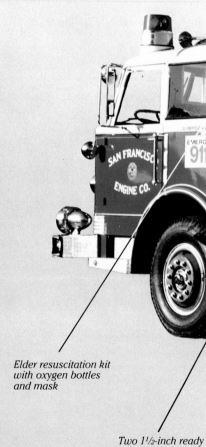

Elder resuscitation kit with oxygen bottles and mask

Two 1½-inch ready lines, preconnected, 200 feet each, with Akron fog nozzles

Rubber tank line on reel for small fires

Multiversal nozzle for long-range, high-volume stream

Forcible entry tools (right side)

Hard suction hoses for drafting water from cisterns or the Bay

1000 feet of 3-inch hose

Four spare Scott bottles

Soft suction lines, hose fittings, tools (right side)

Ropes for lowering hard suction lines into water

22-foot extension ladder

Internal tank holds 500 gallons of water

First-aid kit (right side)

Fire extinguishers and pump can (right side)

Ceiling hook

Hose bumpers permit large vehicles to run over charged hoses without damage

Four Scott Air-Paks with masks

Shovels

2 100-foot small-line hose bundles with Akron fog nozzles

Heber hose clamp for closing off charged lines

Pump panel controls all water movement through various inlets and outlets

Various nozzles and hose fittings

Gleeson valve for regulating water from high-pressure hydrants

Five-gallon cans of "light water" foam mixture

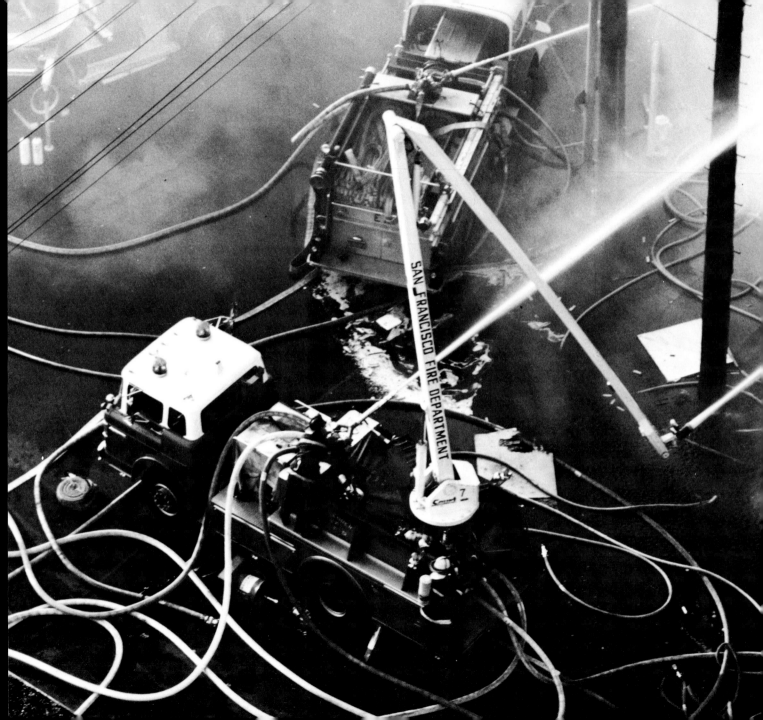

The Crown attack hose tender is used at major fires where large volumes of water in master streams are required. The SFFD has three, and they also respond, manned only by a driver, to first alarms in more densely populated parts of the city.

The rigs carry 2000 feet of three-inch hose, a removable multiversal deck gun similar to those on the engines, and a remote-control articulated arm with a 1000-gallon-per-minute nozzle that can direct a huge stream with surgical accuracy from vantage points up to 54 feet above the street. The hose tender has no pumping capability of its own; it must be supplied through big lines by nearby engines.

Though hose tenders are not due on the first alarm at many locations throughout the city, they can be special-called as required by the chief on the scene. They are driven by members of the Bureau of Equipment, who respond to the three houses where the rigs are kept (Stations Seven, 13, and 21.) Wise chiefs will make a point of summoning the hose tenders to big fire-fights as early as possible, since the rigs must be positioned directly in front of the fire building to do any good.

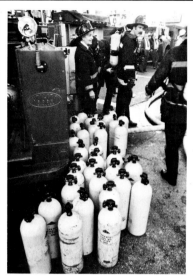

The SFFD has two service squads, one of which responds to every greater alarm. The smaller rig carries spare Scott bottles and oxygen, while the larger vehicle—similar in appearance to Rescue Two—also contains a compressor for filling bottles at the scene. Both rigs cover the city from their headquarters at Station 38.

One of the SFFD's 18 ladder trucks is an oddity: Eight Truck carries a jackknife Snorkel arm with three-man basket instead of a 100-foot aerial ladder. The rig can be used for rescues or for pinpoint placement of water streams up to 85 feet above the pavement. It also carries the usual complement of ladders and tools. Eight Truck's cherry picker is shown being used to retrieve a would-be suicide from a chillly perch on the Bay Bridge.

A fourth division of the San Francisco Fire Department is responsible for firefighting at the city's International Airport, some fifteen miles to the south. Aviation firefighting is highly specialized, and the workday at SFO bears little resemblance to the job in town. A complement of one chief and 60 men staffs two firehouses containing seven pieces of exotic and complicated apparatus.

The airport firefighter below is clad in a metallic "proximity suit" which permits him to survive and fight at the veritable center of an aircraft fire. Behind him is one of the airport's enormous Oshkosh eight-wheel firefighting rigs; these monsters are powered by twin V-8 diesels generating a total of 1000 hp. Since there are no water supplies along the runways, all airport apparatus must carry water and foam on board. The Oshkosh carries 4000 gallons of water and 515 gallons of foam solution in internal tanks; its immense over-cab nozzles can exhaust this supply in only three minutes.

The SFFD's two rescue squads are multi-purpose vehicles that carry a huge variety of special gear. Included in their complement of equipment is climbing and rappelling gear, scuba diving apparatus, cutting and prying tools, the amazing Hurst "Jaws of Life" system, first-aid and oxygen supplies for their many medical responses, and the Scott Air-Paks the members don in most fire situations. "Squaddies" are proficient in the use of all this equipment and more. The beautiful 1956 Seagrave pictured is the relief piece for Rescue Squad Two; many members of the Department consider "Nellie-Belle" their favorite rig. It is powered by an immense V-12 gasoline engine, and it is said to accelerate cheerfully up any hill in San Francisco.

Rescue squad members are qualified scuba divers. Rescue Two's Mike Lewis is about to take a hose line under Pier 70 to attack a persistent fire in the creosote-soaked pilings.

The Phoenix, which shares waterfront quarters with 35 Engine, is the latest in a long line of SFFD fireboats. In the days of steam the boats were a familiar fixture on the Bay shore, since they kept up boiler pressure and spouted plumes of smoke 24 hours a day.

The diesel-powered Phoenix can be away from its slip almost as rapidly as a land-based rig; it is part of most first-alarm responses on the waterfront. The boat is crewed by the men of 35 Engine, augmented by its own officer, pilot, and engineer. The four monitor nozzles and ten manifold outlets on the Phoenix can put out a total of 9600 gallons per minute. It was an invaluable asset in fighting the many gigantic pier fires of the '60s and '70s, but it is less active today. The boat is frequently called upon to act as the city's official greeter, its deck guns hurling water far above the pilot house, when large military and commercial ships visit the port.

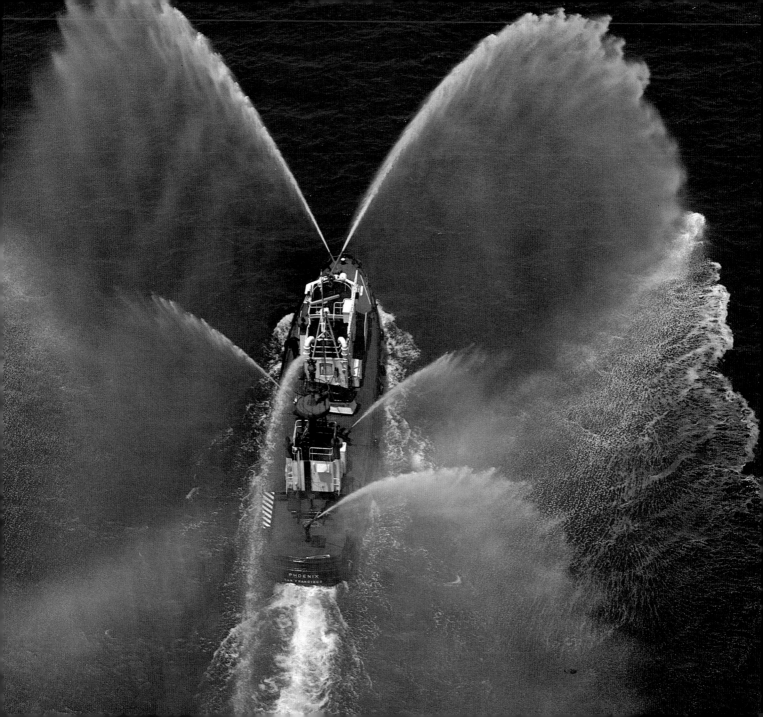

ARSON

The hardest crime to control

Arson investigators Paul Murray and Roger Elbeck search painstakingly for evidence in the aftermath of a Mission District torch job. Overleaf: Revenge arson at its worst. A pair of Western Addition three-flats blaze out of control.

The sexiest arson problem nationally—the one that usually gets the most attention—is arson for profit. It's much more common to the Northeast seaboard cities than it is to San Francisco. In many eastern cities, urban property values have fallen so low that the insurance on a building may be worth far more than its market price. "Profit" is just a torch away.

San Francisco is another story. Since World War II, property values have run well ahead of the nation—indeed, ahead of most of California—because space is so limited within the city's 49 square miles. Few are the property owners who could make more money by torching their places than by selling or leasing the space.

Most of San Francisco's arson has nothing to do with money. The SFFD ranks the causes of arson in San Francisco this way:

1. **Revenge:** arson as a form of assault.
2. **Vandalism:** arson for no reason at all.
3. **Fraud:** arson for profit.
4. **Pyromania:** arson for psychotic reasons.

Firehouse magazine cites these national statistics:

1. **Arson as vandalism, 42%.**
2. **Arson for revenge, 23%.**
3. **Pyromaniac arson, 14%.**
4. **Arson for profit, 14%.**
5. **Arson to cover up another crime, 7%.**

Law enforcement officials "view the increases in revenge arson as yet another signal," noted *Firehouse* (August 1982), "that growing conflicts and stresses in our society are boiling over into serious, violent explosions of arson." In a profile of the revenge arsonist, the magazine warned readers to take seriously normally passive people who sputter: "You wait—I'll get you..." And especially: "If you don't stop it, I'm going to burn you out."

"Arson for revenge is the worst," said one investigator. "The guy is going to make sure his victim's inside, and he's not going to care who else is in there. The guy doing it for money, he's more of a pro, he's probably going to make some effort to hit his building when it's empty."

The very nature of arson investigation—literally sifting through ashes for clues, never seeing the act until its consequences have had an opportunity to destroy the evidence—makes arson investigation more elusive than almost any other area of crime detection. "And you *never* know," said Chief Casper, "how many arsonists there are out there who are sharper than we are, who are making fires *look* like revenge or accidents or nutcase jobs."

For what it's worth, retired professional arsonists love to brag about setting innumerable undetected incendiary fires.

The San Francisco Arson Task Force is an idea so logical that one might suppose it to be a long-standing tradition: fire and police inspectors combining their expertise in fire-related crime detection. Actually it's something relatively new, an idea borrowed from the city of Seattle in 1977.

"When I started as Chief," said

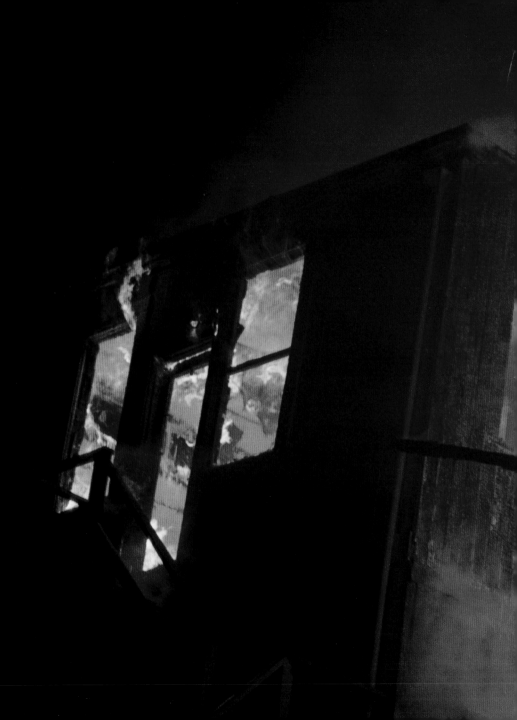

Casper, "we were having our troubles with arson—the rate was climbing—and this task force approach looked like an answer. It combines the efforts of not just the fire and police departments but also the District Attorney's office; they put on a guy to handle practically nothing but arson cases. We also have input from the FBI, the Alcohol, Firearms, and Tobacco section of the Treasury Department, other police agencies, the insurance industry, real estate and banking people."

This represents a great leap forward compared to the recent "old days" when the arson investigators and cops went about their work independently, rarely sharing information with each other. Contacts with other agencies were on a now-and-then basis. Today, all work together on every suspicious incident as a matter of routine. The task force utilizes a computer; all members of the investigating group log their findings immediately. This makes it possible to chart trends and *modi operandi* on, say, an arsonist who has set half a dozen fires in the same neighborhood.

After several months of training and learning to work together, the Arson Task Force began to catch more bad guys than ever before. San Francisco's arrest-and-conviction rate jumped to 10 percent, as compared with a 3 percent national average. The arrest rate went up to 19 percent—and with that, the word got around that this Arson Task Force was *nailing* people.

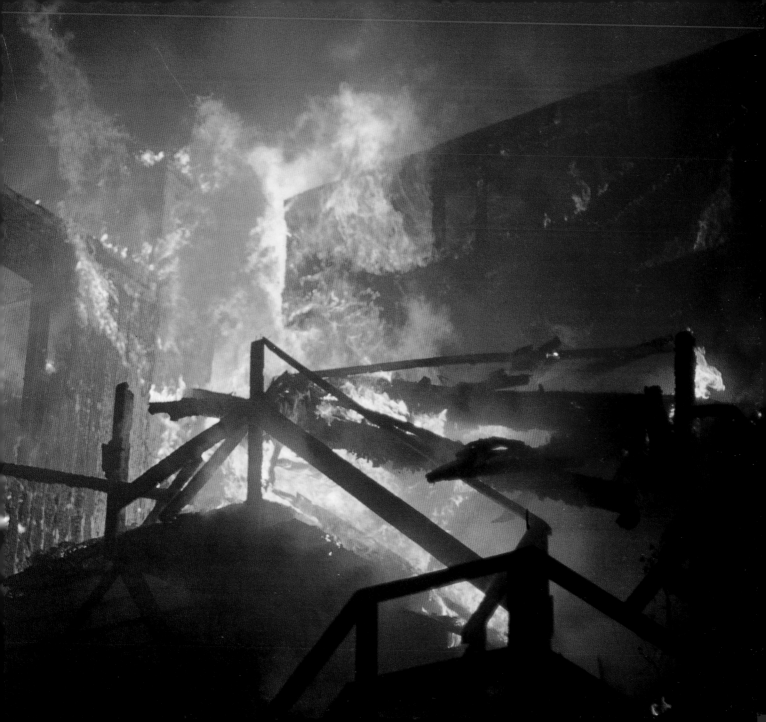

"Arson started to drop," Casper said with evident satisfaction, "and though we've had our ups and downs, we think the task force approach works. There's no way to stop every arsonist, but the task force has put a halt to an impressive number."

The Arson Task Force handles some 900 investigations a year, and of these, roughly 500 are fires that were purposely set. Investigator John Ricketts granted that on a number of these cases he has come back to his findings several times to get the "feel" of the incident, trying to be certain that the cause of the fire was what it seemed to be. It is crucial to get a firm grasp on the evidence if it is to stand up in court.

"We had a long wait before we could finally arrest that guy on the big Polk Street fires. He was a prime suspect; hell, he was *the* suspect, we all knew it. But it took months before we really had him. We have some arsonists who lay back there for quite a time. Months and months. There's a couple of them out there now, and we're waiting for them to do something we can get them on."

Technically, a fire that has been purposely set is an incendiary fire. Once it has been demonstrated to the court's satisfaction that a person is guilty of this crime, that's arson. It's like the distinction between killing and murder; it may be clear that somebody has been stabbed to death, but unless it can be proved who dunnit, it's not murder, it's a killing. The Task Force determines whether an incendiary fire was set and reports to the court who did the deed and how; the court determines whether it was arson.

While one might suppose that the men who fight fires would detest arsonists with a cold fury, this is hardly the case. "When you roll up to a joint that's really going," one veteran captain explained, "you want to concentrate on stopping the fire and saving lives — not getting into some big emotional thing. That isn't going to stop *any* fire. Sure, it might have been some lunatic with a torch. Or some stupid jerk who fell asleep with a cigarette. In fact, if you could somehow eliminate all fires caused by arson and smoking, you'd probably do away with 90 percent of the fires in this town. But that's never going to happen. So when you get there, you've got a job to do. It's up to the arson guys to figure out *why* it happened later."

Inspector Ricketts said he prefers to examine the physical evidence, to reconstruct what must have happened from the remains of the fire, before he starts interviewing witnesses.

"People aren't nearly as reliable as you might think," he said. "Not that people are dishonest, although of course some are. But there are lots of reasons why they'll bend the truth. A kid was playing with matches, for example. The mother isn't going to say, 'Yes, officer, my kid was playing with matches.' She's going to try to protect the kid. In communities where you have people from other countries, they don't understand insurance sometimes, or they're frightened of the authorities. If a fire occurs in their home because of some accident, they feel responsible, and they're sure the insurance company won't pay off. Or maybe their landlord will kick them out. Or the immigration guys will get onto them.

"There are lots of reasons," Ricketts said, "why folks will misrepresent the facts. That's why I prefer to get into the evidence first, such as it is. There's often not much to go on, but it's there once you learn what to look for."

Despite the endless uncertainties, Ricketts and his colleagues often earn the satisfaction of a clear-cut arrest. A few years back, a fellow burned out his girlfriend's apartment in the Mission District. Ricketts had no solid proof, no witnesses, but he *knew* the guy had done the deed. "There was nothing to connect him with the fire other than the fact that he had called her up later and said, 'How did you like the fire?' or some such crack. We didn't have nearly enough to arrest the guy."

Three weeks later, there was another fire at the same address. "I remembered the address when I heard the box on the radio. I responded right away and talked with a neighbor girl who had been awake studying and had seen this guy's car. I knew where he lived, so I ran her right up there in the buggy and showed her a bunch of cars. She identified his, and I went up and felt the hood. Nice and warm. We called in the cops to help with the arrest, and the guy is history now."

PREVENTION

Putting out fires before they start

The San Francisco Fire Department has always stressed fire prevention. There's never been much choice, given the physical layout of the city, the high winds, the wooden construction. The job of fire marshal, overseeing construction of buildings for fire safety, directing building inspections, creating public awareness programs, assumes greater importance in San Francisco than in many other cities.

Rare is the fireman who can get as excited about fire prevention as he can about telling tales of legendary firefights in which he was involved. Chief Condon is the exception. He counts his six years as SFFD Fire Marshal as the most interesting he's spent with the Department, and he's capable of genuine enthusiasm as he describes, for instance, high-rise building safety procedures.

To Condon, the successful battle against a major alarm fire represents something less than total victory. "Those big fires," frowned Condon, "emphasize our failure in fire prevention." One derives the distinct impression that the man could only be truly happy if no fire ever broke out at all. He speaks with great enthusiasm of pioneering high-rise safety work done in San Francisco while he was fire marshal.

Elevators had developed a mysterious—and, for one San Francisco firefighter, fatal—tendency during the early 1960s. People in burning buildings would crowd into elevators, assuming they would be carried to the safety of the ground floor. Instead the elevator might head straight for the fire floor, opening its doors directly into superheated smoke and flames.

Experts around the country were studying the problem, and they soon found the culprit: body capacitor elevator buttons. "These are the buttons," Condon explained, "that will only work if you press them with your finger. They won't work if you push them with a pencil, for instance. There's a little cathode tube in there that only responds to the electrical charge in your body."

Unfortunately, the tube also responds to flames. The fire ionizes the air and a static charge triggers the elevator button, directing the elevator to the worst possible destination. Once the problem had been isolated, the SFFD began working with lawmakers to create a number of new safety requirements. Today, in all San Francisco buildings where elevators travel more than 50 feet, there are smoke detectors on all floors; if one is activated, all elevators will head directly for the ground floor. Signs on every floor advise occupants to use stairways in case of fire. And the elevators can be put into an emergency mode, in which they will respond only to buttons inside the car or the master control panel in the lobby.

"Another result," Condon added, "is that there are voice communication systems built into all the big buildings constructed since then. We can plug in and say: 'This is the Fire Department; stay where you are. We'll be up to move you from the 32nd floor,' or wherever they're stuck. We found in high-rise fires that consistently there was no direction to people who were

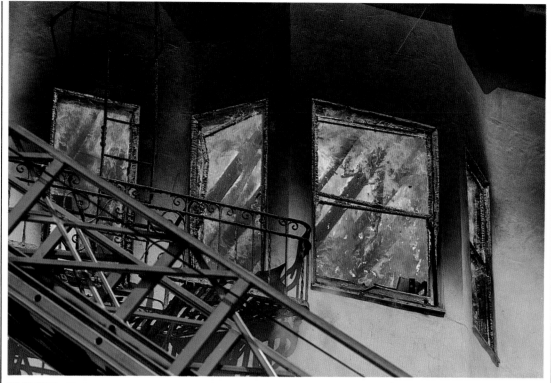

trapped, and they were very bitter about that. They weren't angry with the Fire Department so much as the building management for not having some way of identifying danger areas and telling them what to do."

Condon's study also led to improvements in high-rise air conditioning. In the older buildings, it was possible for climate-control systems to pump hot smoke and combustible gases throughout the building, often turning a small problem into a potential disaster. Today, the law requires a "fire damper,"

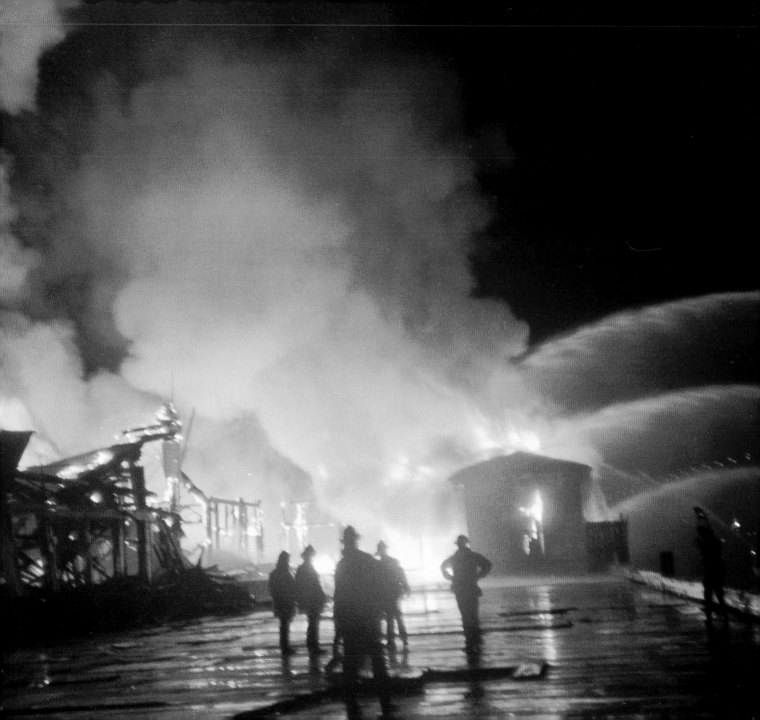

which shuts down the air conditioning when the air becomes too hot.

Condon is immensely proud that no office building occupant has died in a fire during the 35 years he has been with the SFFD. In an effort to keep this remarkable record intact, the Department has created a fire-safety training course; so far, over 400 building management people have taken it.

The SFFD lobbied long ago for sprinklers in all multiple resi-

dence buildings, and today a great many are at least partially "sprinklered." These simple but utterly reliable devices make it almost impossible for a fire to spread in a properly equipped apartment building. A room and contents might "get going good," as the firefighters say, but once the flames break through the door and into the sprinklered hallway, a torrent of water will hold them at bay. "We have a love-hate relationship with the damn things," admitted one fire-

man. "Put in enough of them and we'll all be out of a job. But do they ever work! You can't imagine how big a fire has to be to overwhelm a good sprinkler system."

By all accounts, major fires have decreased dramatically during the past 20 years, to a point where the SFFD rarely goes to more than one greater alarm fire per week. Larger fires are rarer still. There are plenty of reasons for this trend. Programs have been developed whereby firefighters directly counsel juveniles who feel a need to set fires. There is a multitude of fire education programs, including public service announcements on the air. And the news media have become greatly more knowledgeable in their treatment of fires.

"They do a superb job," said Chief Casper of fire coverage in the newspapers and on the air. "As part of their report they routinely give the cause, and lots of times they'll tell why the fire spread, how people managed to get trapped, what various people had done that was wrong. The result is that the public today has a much better idea how to prevent fires from starting—and what to do if they get caught in one."

Casper must take some share of the credit for this. He was masterly at relating on-the-spot fire news to reporters. His forte was delivering perfectly-constructed 30-second reports which could go directly onto radio or TV without need of editing. And always at the heart of these capsule reports were the lessons: why this

fire happened and how the viewer or listener could keep something similar from befalling him.

Casper had a good teacher. The prototype of Fire Chief as TV spokesman was Bill Murray. He was the SFFD's head man at a time when local TV news was still in its formative stages. As the news crews began to get out of the studios and onto the streets, they were naturally attracted to the most photogenic (or *video*genic) news events, with fires topping the list.

More often than not, they quickly found Chief Murray at the scene. He responded to most second alarms, a practice Casper continued. The white-coated Murray stood well back from the blaze and regaled the reporters with a running description of the firefight, combining native wit and a commanding manner with a desire to underline the work his men were doing and to inform the public on the dangers of fire.

Chief Condon restricts his appearances at fire scenes to third alarms and more, preferring instead to concentrate his attention on fine-tuning programs designed, in effect, to put out fires before they start. Most prominent of these is CRISP, initiated when he was fire marshal.

CRISP stands for Commercial and Residential Inspection Safety Program. For two years teams of inspectors and fire companies checked out 21,400 businesses in 12,000 buildings, logging their findings in the department's central computer. Details recorded include dimensions, building

materials, hazardous materials stored on the property, potentially dangerous activities on the premises, and when the inspection took place. In the near future, much of this information will be rapidly retrievable, so that firefighting units at the scene can be advised almost immediately of the special problems they might be facing.

In a more intimate version of this program, the Department has "inventoried" more than 225 buildings it suspects might be targeted for arson, based on the past transactions and personal histories of the owners. Especially interesting to the SFFD are those buildings with convoluted dummy corporations behind them. Of these, there are some 20 corporations or individuals with histories of inordinate brushes with fire. Not all were *necessarily* arson, but there have been far more fires in these

properties than others. As an outgrowth of the Department's arson early warning program (code name: Intervention), a close watch is maintained on these suspect buildings. Fire inspectors continually prowl their interiors seeking fire code violations, hazardous conditions, building code problems, whatever. Their owners would have to be deaf, dumb *and* blind not to get the message.

The SFFD regularly inspects all major buildings in the city as they are being constructed, making sure as few fire hazards as possible are built in. Condon worked with the architects and contractors for the immense Moscone Center, which opened in 1981. The Center people wanted to install thousands of 100-percent urethane-upholstered chairs, but Condon nixed that idea. A catastrophic 1979 fire deep in the BART Trans-Bay tube had taught the San Francisco and Oakland Fire Departments all they needed to know about that substance; burning seatcovers in the BART cars greatly exacerbated the level of the fire and smoke in that terrible battle. Instead Condon suggested (which is all but synonymous with saying "ordered") that they use LS-200 neoprene, the upholstery material to which BART switched.

"It's *great* stuff," said Condon of LS-200, waxing lyrical over its fire-resistant qualities. "You can put a blowtorch on it for five minutes—that's no exaggeration—and the damn material won't burn. Just gives off a little smoke."

Chief Condon meets the press as a fourth-alarm firefight winds down.

TRAINING

Getting, learning, doing the job

To be listed for employment by the San Francisco Fire Department, applicants must pass a number of examinations, among them an entry test evaluating their strength and physical agility. Designed by Frank Verducci, PhD, of the San Francisco State University physical education department, the test is based on the actual work firefighters perform on the job.

Verducci personally observed dozens of fires and analyzed hundreds more from reports. He interviewed a cross section of men about their daily work. On the basis of these studies, Verducci estimated that a firefighter typically puts in 20 minutes of hard physical labor per fire. *Very* hard physical labor.

"The entry test Dr. Verducci put together," says Chief Condon, "has to be the toughest one in the country. It's brutal."

Captain Jerry Grey, one of the officers who teaches new firefighters the arts and sciences of firefighting at the Division of Training, walked us through the test. Its nine "events" were set up around the asphalt parking lot adjacent to the fire college.

The authors of this book urge that no reader attempt to simulate this test without an okay from a physician—and at that, only after building up to it by way of serious conditioning. Most earnest candidates train for months before taking the test, and over half fail.

1. The hose drag. A normal 50-pound hose bundle is laid out on a platform at the same height as on an engine. The candidate grabs the butt of the hose and advances it 30 yards to a yellow line. "It gets heavier the farther you go," said Capt. Grey. "The farther you go, the more you're dragging."

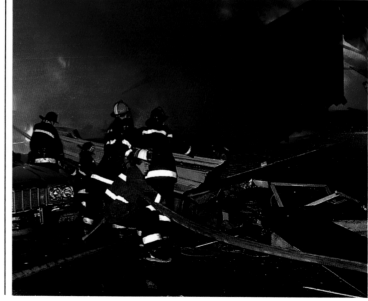

2. The Gleeson valve mount. The candidate picks up a Gleeson from a platform simulating its position on the engine's rear step, carries it to a hydrant, and hooks it up. One catch: this big brass valve (used to diminish water pressure from high-pressure hydrants) weighs 93 pounds. "It requires a bit of a deep-knee-bend maneuver—with strength and balance," said Grey.

3. The hose hookup. The object is to hook up five hoses to hydrants and fittings at various heights and angles, and then disconnect them, all as quickly as possible.

4. The charged hose drag. A "charged" line (with water coursing through it) is awfully heavy. The candidate must drag it 20 yards, kneel, and aim the stream at a target 18 inches across.

5. The run. Endurance is the key to this one. The "running track" looks easy at first glance: a mere 25 yards long, with a truncated staircase in the middle, four steps up, four down. The candidate starts off carrying fire tools back and forth for the first few laps (hose bundle, Gorter nozzle, Akron "Y" hose connector), then completes the race empty-handed—back and forth, up and down, back and forth, until 12 minutes have elapsed. "Dealing with that staircase in the middle," said Grey, "breaks your stride. You can't just be a jogger if you're going to do 30-plus laps. It takes coordination as well as stamina. It's similar to what you encounter when you have to run out to the truck for additional equipment. At fires we

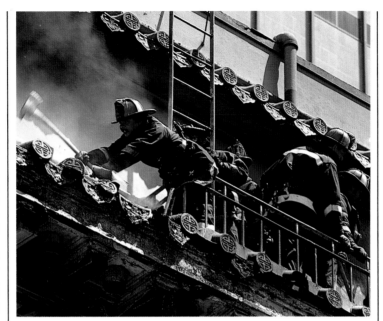

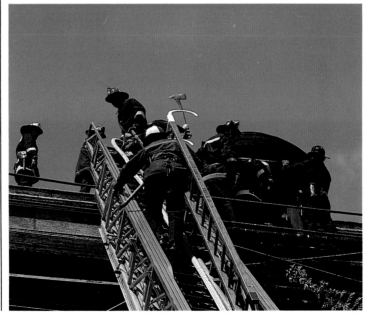

The physical exam is based on the actual work firefighters tackle at fire scenes. A truckman struggles with a charged big line on Hallam Street; a firefighter ventilates with his axe in a Chinatown greater alarm; a truckman lugs a 50-pound roofing ladder to the top of a four-story Pacific Heights mansion.

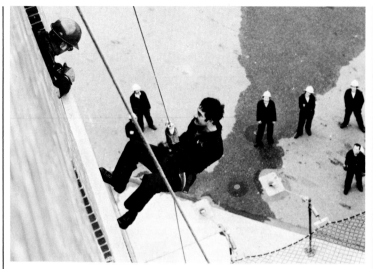

An instructor watches firefighter trainees practicing rappelling techniques at the Division of Training.

go back and forth plenty, and we often have to climb three or four flights of stairs carrying heavy stuff. The question is: Can you get to the rig and back before tomorrow?"

6. The axe swing. The object is to swing an axe (with blade shielded) into a pad as many times as possible in one minute. To register, each blow must carry 50 pounds' impact.

7. The ceiling hook pull. After the flames have been extinguished, firefighters must make certain no "hot spots" remain smoldering in walls and ceilings to flare up later. In some buildings, pulling down ceilings can take much longer than putting out the fire in the first place. Ceiling hooks are long poles with nasty steel hooks at one end. No matter how well-trained a firefighter, a protracted bout of ceiling-pulling can leave arm, shoulder and back muscles

screaming for mercy. In this event, the applicant reaches up with a ceiling hook to pull down on heavy weights suspended from a ceiling-height apparatus.

8. The ladder climb. A 50-pound hose bundle strapped to his back, the candidate hurries up a 32-foot ladder and down again. "This one gives them a little taste of heights as well," said Grey.

9. The ladder lift. Except for the powered "aerial," firefighters must "throw" ladders to the sides of buildings. Working in well-drilled teams, they make it look easy, but it isn't: the 50-foot model weighs 350 pounds. In this event, the applicant must lift "his share." He makes five lifts, each successively heavier as additional weight is added, to a maximum of 135 pounds. The higher the mock ladder is lifted, the more lights are lit on the test apparatus, from zero to three.

(Passing grade is six lights for five lifts.)

"It's a real pleasant workout," grinned Grey, who had taken the test a few days earlier. "You know you've been through something because your muscles keep telling you all about it for days. Firefighters who excel in it will very likely excel on the job. It really is a very close approximation of the work you're called upon to do at a typical working fire. People who can't pass it would have real problems holding up their end."

When we spoke, no woman candidate had passed the test. The biggest problem had been the ladder lift; no woman had been able to lift the ladder high enough to set off a single light. While a well-conditioned woman can generate plenty of leg and hip power — enough to pass the test events demanding that kind of strength — upper-body muscles are another matter.

The explanation for this is physiological; it has nothing to do with determination or courage. Men's hormonal makeup is such that the repetition of weight work builds bulkier muscles capable of generating more power. Women doing the same sort of weight work do not build significantly more muscle and therefore cannot build up their strength as dramatically.

Though women may never become as physically powerful as men, it's quite possible for *some* women to become stronger than *some* men. About 600 women signed up in mid-1982 to take the

firefighter examinations, and it's highly likely that for the first time some exceptionally well-trained women will pass the next time around.

In 1982, the men of the SFFD seemed preoccupied with the question of women as firefighters. Rarely in the authors' presence were there any offensive or sexist comments. "It's not so much that it isn't a job for women," said one firefighter. "The point is that it's not a job for people with small muscles. Hell, a majority of *men* don't pass the test. The job requires a lot of dumb, brute strength."

"There are a lot of jobs," remarked Jerry Grey, "where women are a really important element — not just to be fair to them, but actually to get the job done better. Police work is like that. The big-brute Irish cop days are a thing of the past, where the flatfoot would rule the neighborhood with his billy club. The woman's contribution is genuinely useful — juvenile problems, rape cases, detective work, the male-female cop team handling the domestic dispute, you name it. The woman often gets people to level with her, because they don't feel as intimidated.

"But with fire — fire intimidates everybody, and it's going to require brute power to overcome it. You're pulling victims out, throwing ladders, chopping holes, carrying a hundred pounds of stuff to the fourth floor and then lugging somebody down. You're going to *destroy* the building, if you have to, to get at the killer fire and extinguish it. The vast major-

ity of it is just plain physical work, and psychology or public relations or tough posturing won't cut it. You can't *talk* a fire out."

The male firefighters seemed to want to be fair about this issue. "Hey, if she can pass the test," said one, "that's great. Just so long as she can pull her share.

Because in the big burner we're all depending on each other, and we're all trying to do our part of the rough work." Privately, the men predicted the first women firefighters would enter the department within the year.

To prepare entrance test standards, the Department placed featherweight computers on men in the busier stations and monitored their blood pressure throughout the workshift, both when they were at rest and when they were fighting fires. One of the more startling findings was that it is possible for firefighters

to *over*train for the job.

A large number of firefighters are in excellent physical condition, active participants in marathons, weightlifting, basketball, cycling, and other strenuous sports. In a firefight, their conditioning readily translates to such tasks as lifting, carrying, and dealing with flights of stairs repeatedly, all the while taking heat and smoke.

The trouble comes when the man who is in excellent physical condition pushes himself way beyond his limits. He may feel as though he can handle it, but the stresses on his body inside a burning building are far greater than those inside a gym. The guy who's in less than terrific shape is apt to slow down sooner, physically *and* psychologically. His better-conditioned firemate, meanwhile, may run the risk of working himself almost to death.

This was clearly demonstrated when the men wore their blood-pressure computers while fighting a particularly demanding high-rise fire. One group had to carry fire tools up a staircase to the 13th floor, since the elevators were inoperative. All started up the stairs on a run. Some began to peel off by the fourth floor; by the sixth, all but one had paused to rest. That hearty fellow charged all the way to the 13th floor non-stop.

All the fire stress factors except one were going against him: he was wearing an air mask so, luckily for him, he inhaled no smoke. But he *was* carrying heavy equipment, running upstairs in high heat, placing his body under ex-

Firefighter applicant Terry Loughran takes a crack at the ladder lift, usually the toughest event for women to master.

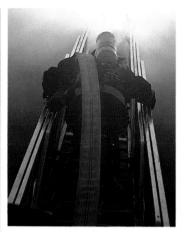

...traordinary physical (and emotional) stress. "The doctor performing the study told us that if there had been the smoke factor working on this guy, his heart could have literally blown up," said Chief Casper. "And this was one of the best-conditioned men in the Department!"

Another surprise was that some men who tended toward higher blood pressure at rest logged normal readings while firefighting. And vice versa. This appeared to be a function of age, with the older men less concerned about a doctor's check-up than their younger colleagues. Their readings at rest reflected their comparative lack of anxiety. But fireground readings for some of the vets were strikingly higher, revealing unanticipated levels of both emotional and physical stress on the job.

Because of the extraordinary physical demands inherent in firefighting, the SFFD began a mandatory conditioning pro-gram in 1982, with companies reporting to training facilities on a regular basis. Weights, stretching, agility drills, running; grunt, groan, sweat. This was occasioned by the none-too-surprising finding that the performance of firefighters over 35 who neglected their conditioning fell off dramatically. When in shape, however, the experienced men could perform with the best.

Once accepted into the Department, the new firefighters undergo one year of training in all facets of the profession. They learn the basics at the Division of Training in the Mission District. The spread, adjacent to Station Seven, consists of classroom buildings, a vast asphalt lot for maneuvering the rigs about, and the Drill Tower, a seven-story brick structure in which most fire situations can be simulated.

The drills and lectures are endless. They work with tools. They drive the rigs. They work out in the gym. Sometimes they deal with smoke and fire situations the officers have created in the Tower.

The men work with ladders, in Capt. Grey's words, "until ladders are coming out of their ears." Ladder work is basic to firefighting everywhere, but in San Francisco there are extra complications. The SFFD clings to its traditional wooden ladders, but it's more than a matter of blind obeisance to the past: overhead power lines are still common all over the city, and aluminum ladders can conduct fatal doses of electricity if allowed to touch, say, an overhead trolley cable. But wooden lad-ders are heavy; the 50-footers require a well-drilled team of at least six to throw them safely, and even the commonly used 35's are a handful for three men. The men also learn to pivot the ladders from one window to another by carefully rotating them at the base. By the time they graduate, they all have the hang of it.

What do you need to know to be a firefighter? Department guidelines, many of them dating to the days when Chief Murray set up the training programs, spell out these critical areas of learning:

1. Use of self-contained breathing apparatus.
2. Hose handling in many varied situations.
3. Use of specialized hand and power tools for cutting and extraction.
4. Hand-raised ladder operations and their safety features.
5. Low- and high-pressure water systems.
6. Ventilation and forcible-entry procedures.
7. Driving and operating various motor-driven apparatus.
8. Fire prevention and arson detection methods and procedures.
9. Portable fire extinguisher procedures.
10. Basic ground operations of truck and engine companies.
11. A catch-all of specialized topics, including first aid and CPR (cardio-pulmonary resuscitation) training, elevator systems and rescues, refrig-

eration systems, the physics and chemistry of fire, toxic products of combustion and their detection, pump theory, drafting and hydrant operations, hazards of plastics to firefighters, hazards of electricity and natural gas to firefighters, radio communication procedures, rules and guidelines pertinent to new firefighters, and battalion-scale drills.

One keystone of SFFD training is that every firefighter with one year on the job will be well-grounded in all procedures, so that almost everybody knows how to do almost everything. Everyone from probie to chief can, in a pinch, lead to a hydrant, drive or tiller a truck, break into a stuck elevator, or cut into a steel door with a Stihl saw.

The successful "Tower" graduate puts in a probationary year on the job, beginning with four months each on an engine and a truck; the company officers act as his on-the-job mentors. After that, he becomes an "unassigned," scheduled for duty wherever needed, waiting for a position to open at a firehouse where he'd like to work.

Permanent "spots" are assigned on the basis of seniority; periodic vacancy lists allow members to bid for a consistent job where they may stay throughout their career. Others will go the "student" route, studying for the officer examinations that can propel them up the career ladder. Officer promotions often have a bittersweet quality, since the

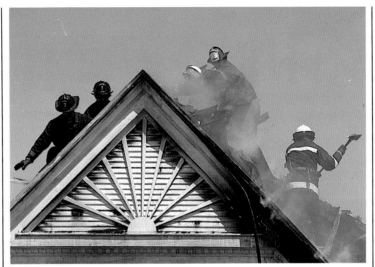

men will usually have to give up cherished long-time spots in desirable houses to move up the command structure.

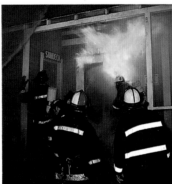

Ten years ago, a group of 30 senior fire officers was convened to determine the characteristics necessary for success as a firefighter. They produced a lengthy list of desirable attributes, which was subsequently boiled down to a 13-point evalua-

tion form by a pair of Berkeley psychologists. In his first year the probie is graded by his superiors on the basis of such qualities as "initiative, dedication (desire, interest and attitude), social relations, teamwork, dependability, oral communications, written communications, response to rules, physical condition and coordination, response to orders, mechanical aptitude, job knowledge, and public relations."

Chief Chuck Lee, recently retired head of training for the SFFD, felt that it could all be boiled down to one word: dependability. "The man has to show up on time, he has to be right behind you when you need him, he has to be willing to put out 100 percent, and that also means being *able* to put out 100 percent. In other words, dependability means qualifying on all the other counts as well."

THE FIRE LIFE

Why they live it, why they love it

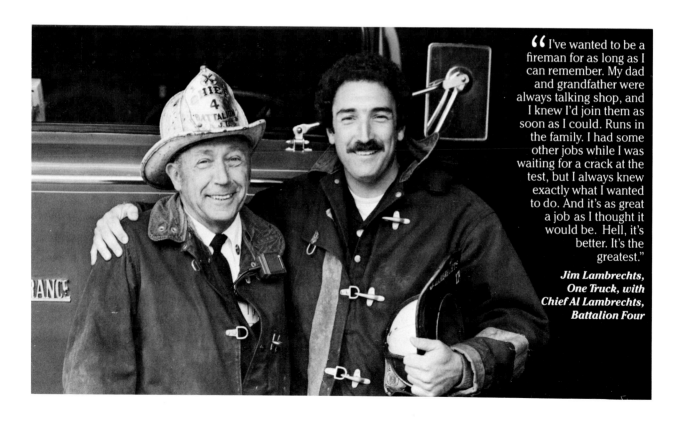

" I've wanted to be a fireman for as long as I can remember. My dad and grandfather were always talking shop, and I knew I'd join them as soon as I could. Runs in the family. I had some other jobs while I was waiting for a crack at the test, but I always knew exactly what I wanted to do. And it's as great a job as I thought it would be. Hell, it's better. It's the greatest."

Jim Lambrechts,
One Truck, with
Chief Al Lambrechts,
Battalion Four

❝ I love this job; we all do. All you do is help people. Not just putting out fires. That's not even half of the calls, at least not in this house. It's stuck elevators, auto accidents, mom locked herself out with the baby inside, a water leak in the basement. Sure, they should have called the plumber, but they called us, so we do what we can. Damn near every day you work, something happens that makes you feel terrific.❞

Ted Corporandy, Five Truck

❝ People call us for all sorts of problems, because they know we'll always be there in three minutes. The word's been out in the rough neighborhoods for years; bad trouble, call the fire department; with the cops, you never know when they'll show up. And it's not the cops' fault; I was a cop before, and you should listen to their radio — constant talk, one call after another, you can't get a word in edgewise. So people call us for muggings, somebody breaking in, arguments with the neighbors, troubles with the heat or broken pipes in some of these awful buildings. People call who are just old and sick and lonely. They *know* we'll always come, and we will.❞

Hal Quinn, Rescue One

❝ My dad was working at the time of the earthquake and fire of '06. Actually, he and his company had spent most of the night before at a big fire on Fisherman's Wharf, and it was the wee hours before they headed home. They grabbed a snack and went to bed maybe a half hour before the shake. Imagine that, climbing into those soaking wet turnouts and then working non-stop for three days. He never saw a bed again until April 21.❞

Chief Bill Murray

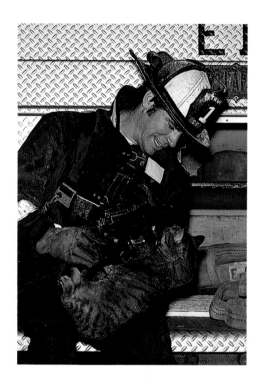

" These guys do a great job helping us. You can really use several people who know what they're doing when you have a cardiac or an overdose or whatever. Doing CPR on someone can exhaust you, just flatten you, in about five minutes. They often stay in the ambulance all the way to the hospital working on people. And they get hurt themselves, all the time. It's crazy. Any big fire you'll have to treat three or four of them—too much smoke, burns around the neck and ears, cuts, stuff in their eyes. Of course I'm not exactly an impartial witness—my dad and brother are firemen."

Denise Voelker,
Central Emergency Paramedic

" This cat was out cold from smoke. I almost stepped on him. I took him out front and gave him a blast of air from the Scott mask; you can put it on 'positive' and it'll blow air out. He coughed a bit and snapped right back. I'm getting good at this—did it once with a gerbil too."

Bill Lafferty, One Truck

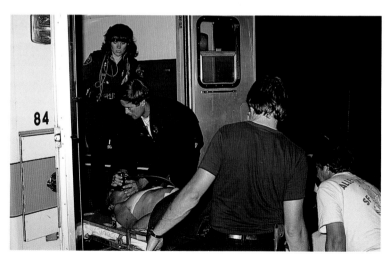

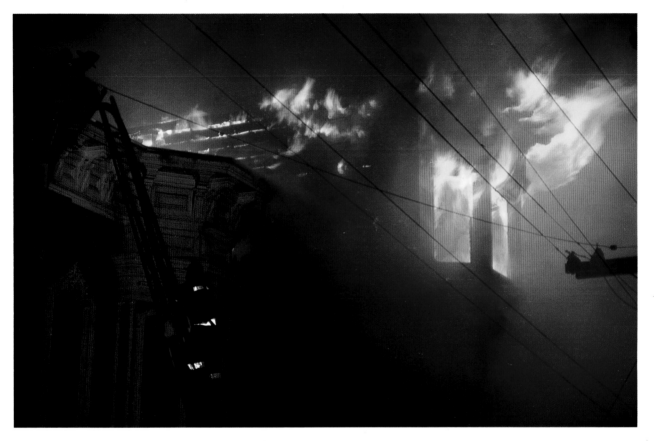

❝ It's a beautiful town. Everybody's Favorite City and all that, and the rows of Victorians really do look wonderful. But they're just made to burn; they can get going top-to-bottom in minutes. At least they vent themselves well, out the top and sides — not nearly so hot inside as brick buildings, which are just like ovens. Visiting firemen stop by the station to talk, and they ask the same question: What happens if you get a joint going good at the bottom of a hill, there's a row of these Victorians marching up the block and the wind's blowing the wrong way? Well, they know damn well what's going to happen and so do we. That's why we believe in putting such a big response on the street — you gotta knock it down right now, or you're going to lose a whole bunch of those little cuties."

Lt. John Tizio, 29 Engine

❝You don't want to wish a fire on anybody; if there were never any more fires, ever, that would be the ultimate. But the slow days with no work, they're the pits. I hate to say it, but we just go whooping out of here when it sounds like a big burner. Then we bounce around the station for hours when we get back—tired and wet, filthy, but still high and excited, rehashing the job, telling war stories. People would think we're crazy if they could hear us after. Maybe we are—running into some joint when everybody else is running out.❞

Mike Lewis with Lt. Tommy Ryan, Rescue Two

❝ We were just clowning here; everybody had just humped it up about six flights of stairs. Most of us try pretty hard to watch our health and stay in shape. The job gets you excited, and you'll put out like crazy when the adrenalin gets flowing. You have to have the conditioning to back yourself up."

Ray Dito with Lt. Ray Balzarini, Rescue One

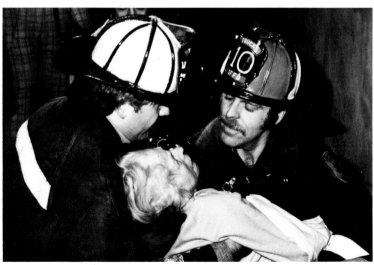

❝ I started in on paramedic training on my own time when I was a probie. I was working on an engine in the South of Market, and there were so many old people down there. Still are. You'd have one going away on you, you wouldn't really know what to do to help, and then Radio comes back with, 'Ambulance delayed; estimating fifteen minutes.' I felt I had to learn a higher level of medical skill, even though it's not supposed to be part of my job. There's about three hundred of us now with some level of EMT skills; I guess they felt the same way."

Craig Brown, 10 Truck

> " The ladder pipe isn't for everybody. Obviously, you can't be bothered by heights. I actually like being way up there — it gives you a fantastic view of the whole fire, of what everyone's doing. But the damn ladder bounces and wobbles all the time. You just have to hook up your safety belt and then enjoy yourself."
>
> **Larry Massetani, *Five Truck***

❝ I didn't look so hot that night, and I didn't feel so hot either. My Scott had run out of air, so I headed downstairs to get a new bottle. One problem—no stairs. Half the staircase had collapsed, and it was pitch black in there. I'm in a hurry because I can't breathe. I fell 15 feet—grabbed for the banister and dislocated my shoulder. Pulled it right out of the socket. The fall was like slow-motion; I remember thinking, 'Is this the way it ends?' I think I was more angry than scared. The shoulder still bothers me most of the time."

Eddie O'Brien, 31 Engine

❝ I was a cop before; so were lots of these guys. It seemed like a great way to help people, but no one appreciated you. You got real hard and cold, real quick. You were supervised to the nth degree by people that hadn't come out from behind the desk for years. Here your boss—even the chief—is in there or on the roof taking the same beating you are. Taking the same heat, soaking wet, snot coming out of his nose—if anything, he's out in front of you."

Jim Sweeney, 36 Engine

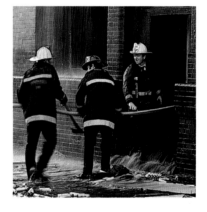

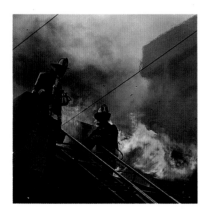

❝ When I first came to work this house, I used to get restless if days went by without a fire. By now I've seen an awful lot of fires, so if there's no action, OK. But when there is a fire, you want to *be* there. You hate clustering around the radio to listen, or reading about it in the paper next day. It's like being a race car driver. You don't want to be sidelined because the car's broken or you're number two driver or something like that. You came to race, right? *We* came to race."

Roger Monks, Battalion Two Operator

" It's an old tradition in the firehouse: cook something really nice, something delicate or tricky that has to be taken out of the oven at just the right time, and sure enough you'll get a big job that will keep everybody out until midnight. When you get back you don't care if it's cold or tough or whatever. You're still pumped, and excited, and of course starving. Anything will taste good."

Lt. Steve Freeman,
Division of Training

" I guess the word's out that we eat pretty well in the firehouse. Well, it's true. We buy all our own food, and some of us get going with some serious cooking. Everyone will have to cook now and then, but usually we fall back on the better chefs. The dishes? We play liar's dice, and the losers wash."

Gene Murphy, 38 Engine

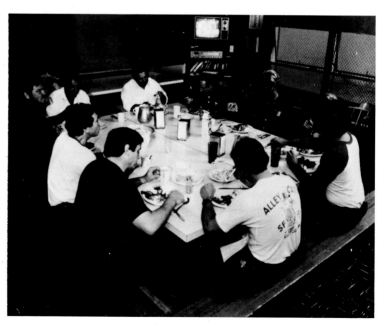

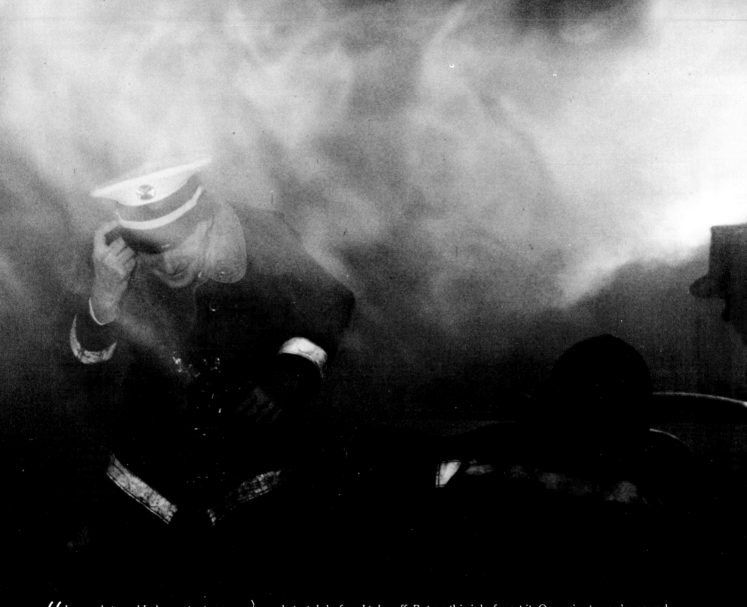

❝I run a lot, and I always try to warm up and stretch before I take off. But on this job, forget it. One minute you're sound asleep, next minute you're exploded out of bed and onto the rig. All of a sudden it's cold; you're still trying to wake up. Two minutes more and you're humping up four flights of stairs, breaking down a door—smoke, extreme heat, wearing all this heavy gear. It's like jumping in your car and flooring it up to a hundred when it's stone cold. How long do you

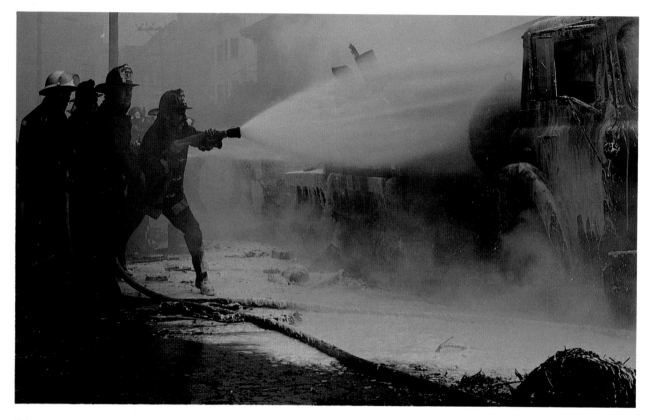

❝ It's ironic—I've been to hundreds of big fires, but this one was probably as close as I ever came to catching it. I was working as Captain of Sixteen Truck in the Marina, and the engine goes out the door for a car fire. In a minute they're back on the radio reporting it's a roofing truck, and they want a full box. We roll up, and I take one look at this damn truck, it's burning from end to end. This thing has a butane tank on it as big as a Volkswagen, and the driver is yelling at me that he's just finished filling it up. So I call for a second alarm; I guess I want someone to come in and pick up the pieces if this thing goes off. We get water and foam on it right away to cool it down, and everything comes out all right. But I can remember just staring at that tank, with heat waves all around it, and thinking, 'That thing goes up and there won't be anything standing for three blocks.' It's what they always say on this job: you go out the door and you *never* know what's next."

Capt. Dan Kiely, One Truck

❝ Any time there's a fire in a movie or on TV, the firemen are standing there in the joint with bright flames all around them. Like *Towering Inferno.* Christ, it's never like that. You're on your knees or flat on your face, trying to crawl up the hallway, you can't see six inches. Lots of times you'll feel the fire and hear it roaring but never see a thing. Just aim the line in the general direction and hope for the best."

Lt. Paul Tabacco, 36 Engine

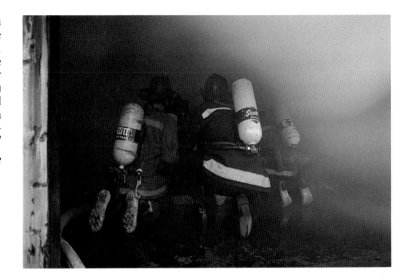

❝ There's a closeness that's hard to describe. Partly it's because we spend a lot of time living together—almost as much as with our families. But more than that, it's because we get in these life-and-death struggles, combat situations really, and we all know that we can depend on each other to be right behind us, backing us up. These guys have bailed each other so many times there's no way to count it. You get in a jam, they'll be coming for you, no matter what. It's a great feeling."

Capt. Gary Torres, Seven Engine

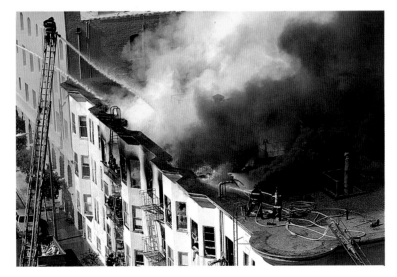

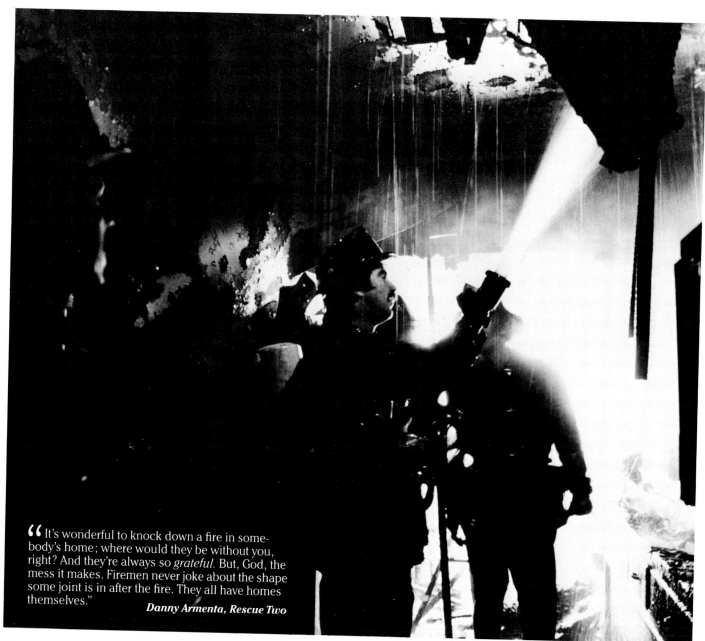

❝ It's wonderful to knock down a fire in some-
body's home; where would they be without you,
right? And they're always so *grateful*. But, God, the
mess it makes. Firemen never joke about the shape
some joint is in after the fire. They all have homes
themselves."

Danny Armenta, Rescue Two

" The night Herb Osuna died, I was next to him on the one-and-a-half-inch line. His last thought—I mean the last second of his life on this earth—was about getting us backed out of there. I'll never forget that. I called home when we got back from the hospital. I didn't want the wife and kids hearing about it on the news when they woke up. I wasn't hurt that bad, but you know how the papers can make it sound sometimes."

Lt. Frank Cercos, Rescue Two

" Yeah, I admit it—I can't stay away. You hear that something good is going, or you see smoke across town, you go to watch like everybody else. You'd think we get enough of it on the job! The joint was jumping at this fire, third alarm companies were on the way in, the smoke was awful and guys were lining up for new bottles. So I figured I'd make myself useful."

Walt Baptiste, Five Truck

" We're very, very good at what we do, and we know it. It's hard to be humble."

Jack Pacheco, One Truck

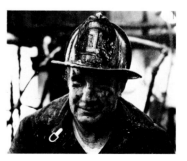

Death of a Battalion Chief

Herb Osuna was the captain of Station One, the SFFD's busiest house. He was in line to move up to battalion chief, and he was going out as chief of Battalion Two to get real-life command experience. On July 31, 1980—his first night back after a month's vacation—he responded on the third alarm to a fire at 256 Montgomery in the Financial District.

The fire building was an older four-story brick office structure with flames blowing out front and rear on the top floor. Osuna led a group of men, mostly from his old house, up the rear fire escape and then along an interior stairway toward the top floor. As the men were advancing slowly up the stairs behind a fog nozzle, Osuna's finely tuned instincts

sensed disaster—a telltale rumbling and splintering in the timbers above him, perhaps. He lifted his Scott mask and yelled, "That's it! Back out!" With that, the wall and roof above the stairs collapsed, sending 15 firefighters tumbling in a heap to the third-floor landing. When they regrouped, all were accounted for except Osuna.

If there's a life involved, firefighters will give it all they've got, and if the life is one of their own they'll give even more. Dazed and injured firemen crawled up what remained of the stairway and found Osuna crushed beneath a jumble of bricks and plaster. They began clawing at the smoldering rubble in hopes of saving him; a chief's operator called frantically on his radio for more manpower and heavy lifting equipment.

"For a long time," Chief Condon recalled, "we couldn't get him out." Paramedics were brought in to minister to Osuna on the spot. Condon told them: "Listen, I'm going to take you to this guy. You're going to have to feel around for him because you won't be able to see anything." One medic crawled deep into the mess, located Osuna and tried to find a pulse at his throat. Nothing. Condon sent for the SFFD chaplain.

Osuna was finally pulled from the wreckage and rushed to San Francisco General Hospital, with medics doing their best to bring

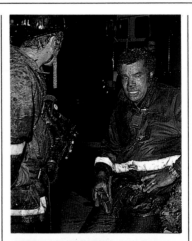

him around even as the ambulance hurtled along. He was pronounced dead shortly after arriving at the hospital's trauma center.

Herb Osuna was buried as a battalion chief in a full-dress funeral with hundreds of San Francisco firefighters and police,

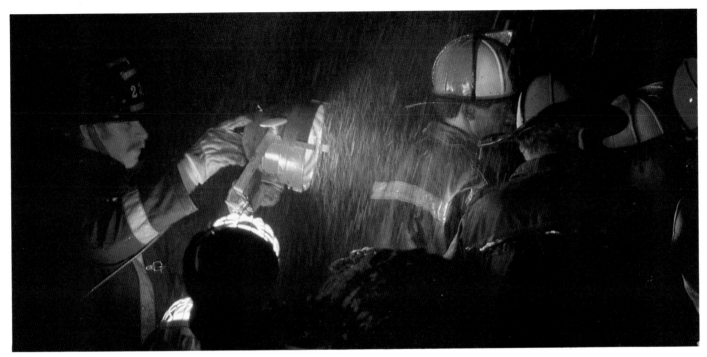

as well as representatives from many California departments, in attendance. Osuna's rig, One Engine, bore a black wreath for a month thereafter, and all Station One members wore their badges draped in mourning.

For the third July in a row, a San Francisco firefighter had lost his life in the line of duty. Two years before, Jimmy "Bucko" Desmond of Six Truck had broken his neck in a fall from a burning stairway; and Zeno Contreras of Seven Truck had suffered fatal injuries in a fall the previous year. Happily, there have been no on-duty deaths in the SFFD since.

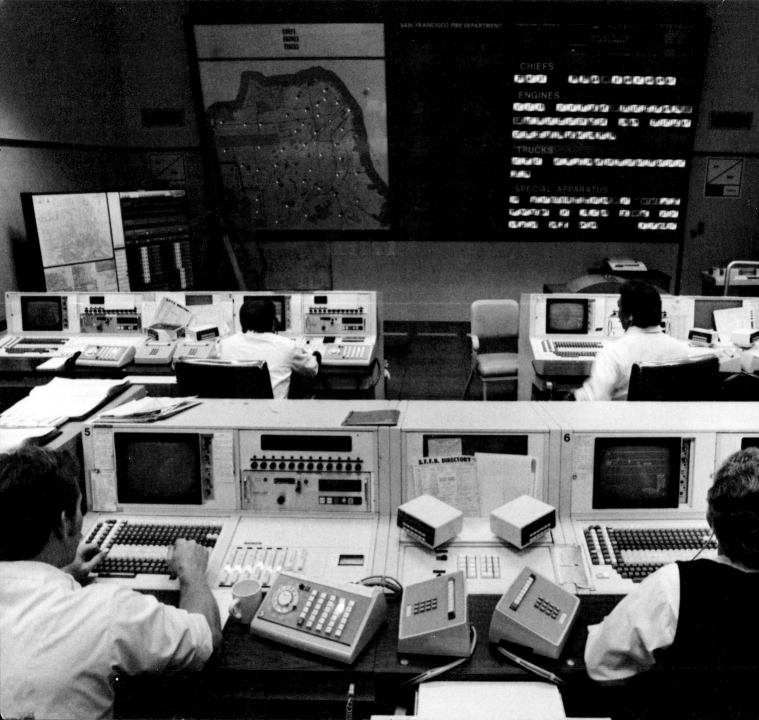

COMMUNICATIONS

The Comm Center calls for good, cool, swift judgment

The dispatchers who work in the SFFD Communications Center can practically tell the day of the month by looking at the monthly incident total on the big board. "It's amazing, but it runs at a steady 100 per day, year round," says Lt. Rich Kain. "Not exactly, of course—and a bit above that in the summer—but generally if the total is sitting at, say, 2350, then you can bet it's the 23rd."

Another changeless figure, year after year: of all the 40,000-odd incidents handled annually by the Comm Center operators, about a third are false, another third are fires, and the remainder run the gamut—medical calls, lockouts, water leaks, auto accidents, the stuff firefighters call "cat up a tree."

The Comm Center—usually referred to as "Radio"—is situated at the same Turk Street location as its nineteenth-century predecessor, the alarm office that was devastated by the '06 quake. It's an exotic facility, bearing passing resemblance (on a more compact scale) to NASA space command headquarters. A huge illuminated wall board contains a map of the city with a light for every company and chief; other rows of lights denote the status of every major piece of apparatus operated by the SFFD. If the light for Eight Engine is green, that means it's rolling down the street but available on the radio. White would mean it's in its station, ready. Orange, out of action due to maintenance or cutbacks. Red means it's at an incident.

There are six separate consoles, positions for six dispatchers to work independently. Eight TV monitors can go split-screen to display the status of 25 incidents simultaneously. It's a capability that one hopes will never be necessary.

All dispatch is computerized; the age-old pegboards and card files have been replaced by state-of-the-art data processing equipment programmed with response information for every address in San Francisco. One of the dispatchers will get a phone call, and he'll type the address into his keyboard. Without skipping a beat, the computer will tell him which companies to dispatch to the address. It all happens in seconds.

As he types in the first two letters of California Street, all the "c-a" streets in the city appear listed on the screen. When he adds the "-l-" all but the "c-a-l" streets drop out. By the time he's gotten to "c-a-l-i-f-o" all have dropped out but California, and he then punches in the street number. The computer comes right back on his terminal with the nearest fire alarm box number, the cross streets, which units are due, schools or other significant structures nearby, the surrounding ("vicinity") street boxes, the water pressure at the closest hydrants, and the order of units that will turn out if the incident should progress to multiple alarms. Should any of these "due" companies be out of service on something else, the computer will bring up the next company in the order.

The dispatcher's next move is to hit his alarm button, causing a distinctive *beep-boop* tone to sound in all houses where units are due. He then goes on the radio and says: "Box 1519, Union

Above: Comm Center board records the status of every piece of apparatus with multi-colored lights. Left: Division chief at a greater alarm communicates with companies inside the fire building via walkie-talkie. Right: Fire alarm boxes are a holdover from the nineteenth century. Most people today use the "911" emergency telephone system to summon help, while street boxes generate mostly false alarms. They remain a valuable aid, however, for the many people in the city who speak little English.

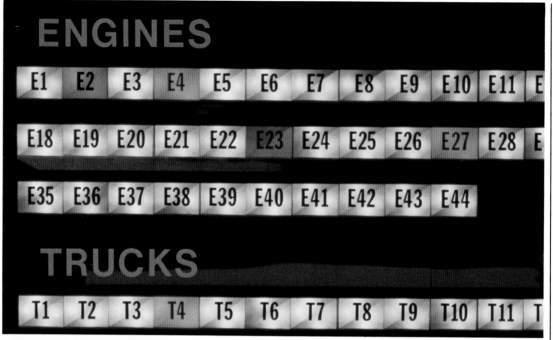

ENGINES

E1	E2	E3	E4	E5	E6	E7	E8	E9	E10	E11	E
E18	E19	E20	E21	E22	E23	E24	E25	E26	E27	E28	E
E35	E36	E37	E38	E39	E40	E41	E42	E43	E44		

TRUCKS

| T1 | T2 | T3 | T4 | T5 | T6 | T7 | T8 | T9 | T10 | T11 | T |

and Jones, the reported address is 1920 Jones Street, units due are . . . " The appropriate companies and chiefs are then listed in the order due.

They take no chances at Radio. In a city built principally of wood, they hate to give fire a chance to get rolling. A person might phone to request, in a calm voice, a little information on how to put out a small fire that's going on in his kitchen. No, he hasn't been able to put it all out yet, but he's sure it isn't going to take off. The men in the Comm Center (all firefighters themselves; there are no civilian dispatchers in the SFFD) know that such a situation could quickly

burst out of control. So rather than simply telling the fellow what to do—which *might* work in four out of five cases—they'll "strike a box," sending a full first alarm howling to the address.

For a small rubbish or car fire, the dispatcher might send a single engine, but it depends on the call he's received. Smoke coming from a dumpster at the curb? A "unit dispatch" for a single engine. Trash on fire in an apartment's garbage chute? In that case, strike the box—give the full treatment. A report of a car on fire will get one engine. But several phone calls reporting a car fully involved in flames will put a first alarm on the streets. "Believe it or not, people will report their car on fire and neglect to tell you it's in their garage," said Kain.

A huge fourth- or fifth-alarm fire will leave a large part of San Francisco stripped of fire protection. When several alarms come in on a single blaze, an assistant chief will respond to the Comm Center to supervise the rearranging of the other companies around town. These "cover companies" will be sent to empty firehouses near the big fire in an effort to equalize firefighting protection across San Francisco. They will remain at their cover spots until the working companies return home, get cleaned up, and reorganize their gear.

The dispatchers control and orchestrate the fire response from their consoles in the $2 million Comm Center. Through their headsets they can speak directly to the firehouses, the units in the field, the police, Central Emergency for ambulance support, the phone company, PG&E, and dispatchers in surrounding cities. It's a job calling for good, cool, swift judgment.

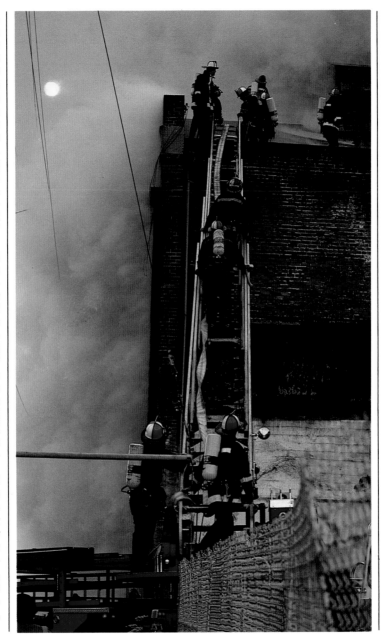

Tuning in to Radio KYO 980

SFFD radio dispatches are transmitted from antennas atop Twin Peaks, and listeners equipped with scanner receivers (price: $100–$300) can pick up the communications from most locations around the Bay Area. Five UHF frequencies (488.362, 488.562, 488.762, 489.162, and 489.187 mhz) have been assigned for Department use; the channels have been designated Control 1 through 5. In general, each of the three firefighting divisions in the city uses one of the first three channels, while Control 4 and 5 are mainly for tactical communications at the fire scene.

In addition, Control 5 carries paging transmissions to the 50 or so "beepers" carried by everyone from the Mayor (call sign 4500) to the mechanics from the Bureau of Equipment (the 4620s). All important boxes and dispatches are sent out simultaneously on Control 1, 2, 3, and 5, while two-way conversations involving specific incidents will then take place on just one of those channels.

All transmissions except those at the fireground are "repeated," or retransmitted citywide from relays on the Peaks, so that any unit in town can be heard by any other despite intervening buildings or terrain. Several relay receivers for each channel are also scattered around the city at different high spots, so that even the low-power walkie-talkies will have a good shot at solid reception; these so-called "voting" receivers pipe their signals into the central system via phone lines.

All radio traffic and all phone calls to the Comm Center are recorded on an 18-track tape that also takes down Ma Bell's time signals; thus every word can be keyed to the precise second it was uttered. This can be invaluable in case of disputes about response times ("It took the damn firemen 20 minutes to get here . . .") or exactly who said what to whom. All in all, the SFFD's radio and computerized dispatch systems are considered the most complete and sophisticated anywhere in the fire service.

Eavesdropping on SFFD communications (perfectly legal, by the way) calls for a few hours of practice before the terms and rhythms become familiar. At first every announcement will sound like an invitation to the apocalypse, but in fact, as with all public service radio chatter, over 95 percent of communications are boringly routine and uneventful. It takes a good ear to sift out the hints and tip-offs of the really big burner from the endless stream of false alarms, beeper calls ("4710, land-line your office Code 2") and minor incidents.

After the dispatch, the first company and the first chief to arrive at the incident will report "10-97" ("on the scene") to Radio, and the ever-turning tape will record the time of their arrival. The first officer to roll up will give a preliminary report, usually one of four simple phrases: "nothing showing," "under investigation," "smoke showing," or the big one, "working fire." The first phrase means just that; the second usually means that a citizen is gesturing toward a situation that isn't yet apparent. The third and fourth mean it's the real thing, the latter indicating visible flames.

Hearing either of the first two over the radio will cause other responding units to take it a bit easier in their rush to the box, while the latter two will start the adrenalin flowing. Radio will repeat the "smoke showing" or "working fire" report to make sure everyone on the system knows that something's cooking. "I don't think I'll ever hear that 'working fire' over the squawk box without my heart doing a tap dance," said one veteran officer.

The real excitement on the radio comes from listening in on the command channel, usually Control 4, at the fire scene. Officers, chiefs, and operators inside the fire building, their voices muffled as they shout into the radio mike from behind their Scott masks, report their actions and yell for further assistance as the firefight progresses. At a huge multiple alarmer, the lone channel crackles with chatter as other radio users — arson

investigators, rescue squad members, men from the Bureau of Equipment—jam in their two bits' worth. These tactical communications are not repeated through Twin Peaks, so the transmissions usually can't be picked up on a scanner from more than a few blocks away.

Herewith a brief list of the most common phrases heard over Radio KYO 980, voice of the SFFD:

"**Fire in the building**" Accompanying the dispatch of a full box, it means that the operator has just gotten a very serious phone call. Wait three minutes for the first report from the scene; if it's "**working fire**," then something yellow is blowing out the window.

"**Code 8**" A street box has been pulled with no other phone call to back it up, and just one engine will be sent since the probability of its being false is extremely high. A frantic "**give us a box**" from the lone engine will mean it's that one-out-of-20 surprise, but more likely is a low-key "**Code 4**" a few minutes later— no further help needed.

"**Smoke in the building**" There's smoke all right, but it's usually from something left too long on the stove. Almost never a real burner.

"**Check an extinguished fire**" Often a real surprise. More than a few of these calls have exploded into greater alarms.

"**Resuscitation**" A single engine or a rescue squad will often be sent on medical emergencies involving cardiac arrests or other types of collapse. A city ambu-

lance will also be dispatched "**Code 3**"—full-tilt with red lights and siren.

"**Vicinity box**" The veterans' ears will perk up on this one. A box will have been dispatched a few moments before, and now a street box is coming in from a block or two away. It's an almost sure sign that something is really burning. One engine will be sent to check it out just in case it's actually a different incident; that engine will then roll on to the first incident if needed.

Pay attention to the **dispatcher's tone of voice.** They're relaxed professionals and they never sound even vaguely hysterical. But when a panic-stricken

caller with trembling voice has phoned in something frightful, this urgency carries over in the operator's on-air announcement. This phenomenon is not easily described. It's like the clicking of a rattlesnake: the first time you hear it you know what it is.

Bells ringing like crazy in the background is an indication that many citizens are calling, and they're probably reporting the same incident. This tip-off background noise is frequently followed by an announcement to the responding units: "**We are now receiving many phone calls.**" That advisory message will get even more hearts thumping than "working fire."

Teletype machines in each firehouse print out dispatch information as the alarm is sounding.

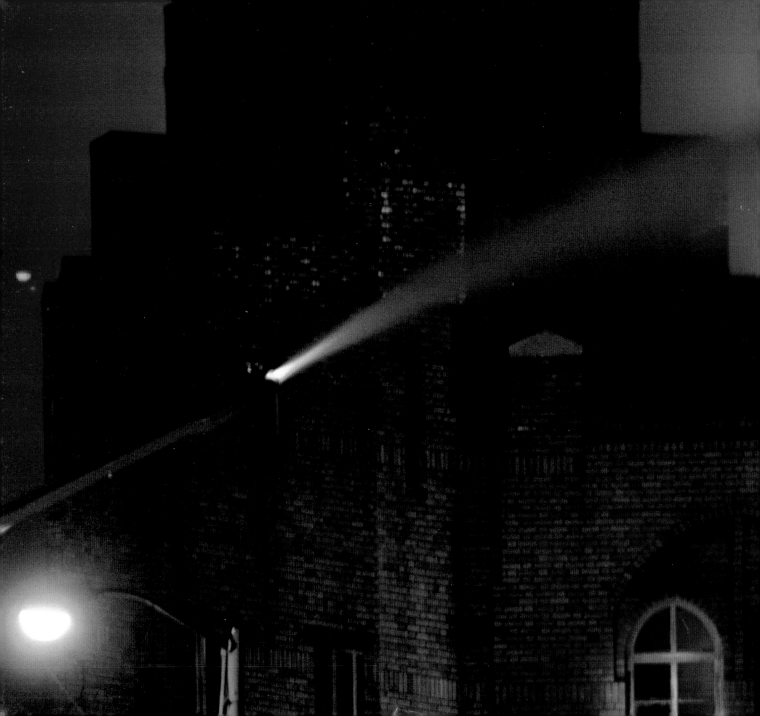

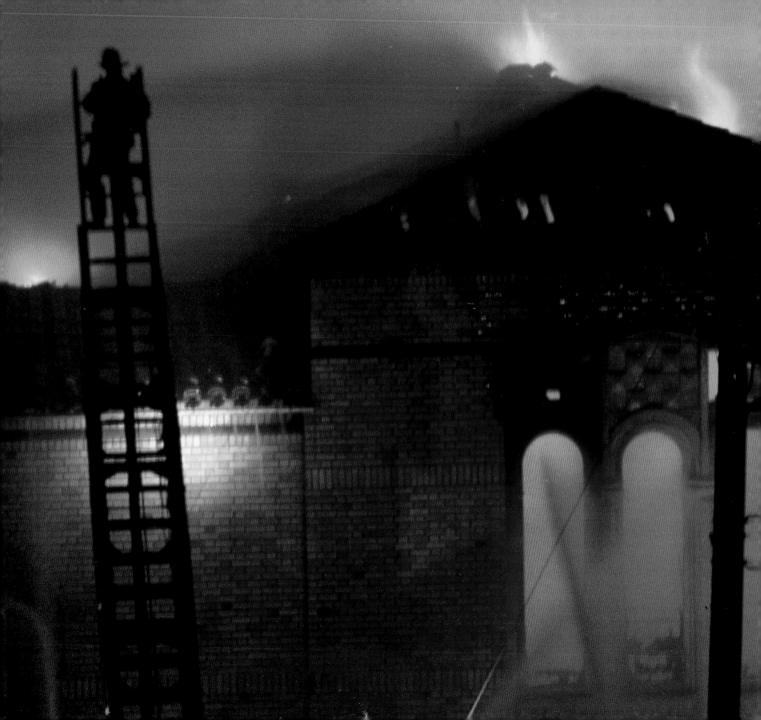

GLOSSARY

Being a Compendium of Useful Words & Phrases as Uttered by the Firefighters of the SFFD.

Note: Many of the following are universally applicable; some are unique to the SFFD.

Aerial.
(Short for **aerial ladder**.) Mounted atop the fire truck on a turntable, this powered ladder extends 100 feet, quickly providing access to roofs or windows as high as eight stories. (See also: *ladder pipe*.)

Akron "Y."
A hose connector which permits two hose lines to be fed by a single line from the engine.

Back out.
As in, "It's time to back out of this place." Retreat; regroup in a safer place.

Battalion.
The SFFD is split into four divisions, three in the city, one at the airport. The three city divisions are subdivided into a total of 10 battalions, each under the command of a battalion chief.

Beep-boop.
Bells used to count out the boxes in all the houses citywide—even in stations not due. Now the computerized dispatch system sounds a two-tone alarm in the specific stations being called to action. The term is a good approximation of its actual sound.

Big line.
A three-inch hoseline, the largest used by SFFD; it puts out high volume of water in what is called a "master stream." Used at major fires.

Bottles.
Generally refers to compressed air tanks for use with Scott Air-Pak breathing system, but also refers to tanks filled with other gases. Most common at firesites are compressed air bottle (yellow) and oxygen (green).

Box.
One of 8000-odd streetcorner pull boxes connected to the Communications Center at Turk & Laguna streets. The term *box* is also intradepartmental lingo for an assignment to cover a fire.

Buggy.
This is how firefighters invariably refer to any departmental automobile. It dates back to an earlier era when fire chiefs arrived in buggies drawn by swift steeds.

CD1. CD2. CD3.
CD1 designates Chief of the Department. CD2 and CD3 are the department's Deputy Chiefs.

Charged line.
A charged line is a hose with water coursing through it. Hoses are dragged into buildings dry, then charged, because a charged line is extremely heavy to maneuver.

Chief's aide.
The chief's right-hand man. Most visibly, he's the fellow who drives the chief to the fire, but he also serves as secretary, handling paperwork and acting as the chief's eyes and ears at the firesite. (See also *operator*.)

Conflagration.
The next step up from a large fire, generating high heat and towering flames. The simple application of water will not stop it initially. The 1981 Folsom Street Fire, the biggest fire since '06 in San Francisco, was a conflagration. (Next order of magnitude is a *firestorm*, which is what happened in '06.)

Division.
The SFFD is split into four divisions, three in the city, one at the airport. Each division is commanded by an assistant chief. (See also *battalion*.)

Engine.
See *fire engine*.

Evolutions.
As firefighters advance on a fire, hose teams move forward to new positions. These position changes are referred to as evolutions.

Exposures.
Surfaces on adjoining or nearby buildings which may be exposed to fires.

Fire.
The Fire Science Dictionary by Boris Kuvshinoff (Wiley-Interscience, 1977) defines *flame* as "the hot, light-emitting portion of a combustion process; the heat-producing, usually visible part of the fire," and says *fire* is "uncontrolled combustion involving flame. Often accidental and unwanted. Generally a fire is the rapid oxidization of a gaseous, liquid or solid fuel in atmospheric air."

Fire engine (or: **engine**).
The engine pumps water onto the fire. Engines were called engines back in the days when they were drawn by horses. (See also: *fire truck*.)

Fire line.
Border at perimeter of firesite which only firefighters may cross.

Fireman/firefighter.
In the old days they were called *firemen*, and still are by most people. But in post–World War II years, in an effort to upgrade the image, many firefighters, especially chiefs, have made a determined effort to call themselves *firefighters* and urge that the media do likewise. Meanwhile, many firemen still call themselves *firemen* out of habit or perhaps tradition.

Firestorm.
A large fire grown to an intensity beyond firefighters' capability to contain or control, generating its own winds and unpredictable direction, capable of swallowing up whole city blocks in a gulp. The '06 Fire was a firestorm with temperatures up to 2700 degrees (F), literally causing buildings to evaporate in its path. (See also: *conflagration*.)

Fire truck (or: **truck**).
The truck is called by that name because it is used to carry heavy equipment—principally ladders, also other fire tools—to the scene of the fire. Trucks were called trucks back in the days when they were drawn by horses. (See also: *fire engine*.)

General alarm.
A fifth alarm, which puts almost half of the SFFD's 320 on-duty personnel at a single huge fire.

Gleeson valve.
A 93-lb. brass device made especially for the SFFD to lower pressure from high-pressure hydrants to manageable level.

Gorter nozzle.
Takes its name from an SFFD engineer who designed many well-known pieces of fire apparatus. This one is a long brass nozzle used as heavy artillery, to lay down a powerful stream of water over a long range. Lacks the versatility of more modern nozzles, but compensates by its punch.

Greater alarm.
A second alarm or more. Five alarms is the maximum in San Francisco, although "special calls" can augment the force. (See also: *special call*.)

High-pressure hydrant.
Tall hydrants fed by a water system separate from the one leading to regular hydrants. The pressure is 160–300 lbs. Generally used at fires of some proportions.

Hose tender.
A smallish vehicle used to convey extra hose for use in major fires. It also carries other apparatus and has an articulated (unmanned) hose arm mounted on top which can direct water onto high spots with surgical accuracy.

Jaws of Life.
Formally called the Hurst Forcible Entry Tool, this machine can cut or separate almost any material. It is commonly used to extract injured motorists from crushed vehicles. Its hydraulic pump is powered by a small gasoline engine.

Joint.
As in, "The joint was really going!" A universal term meaning almost any burning structure, whether it be house, hotel, parking garage, hospital, bar, apartment, theater, store, etc.

Knock it down.
As in, "Let's get in there and knock it down," meaning extinguish the fire.

Ladder pipe.
A high-volume nozzle mounted atop manned aerial ladder, used to direct a heavy deluge onto major blaze. (See also: *aerial.*)

Leads (or: **hose leads**).
Hoses leading from fire engine toward the fire. The term is used to distinguish between hoses applying "the blue stuff on the red stuff" and those relaying water from hydrants to engines.

Low-pressure hydrant.
A short hydrant with a white top, sufficient for most fire situations, with 40–60 pounds water pressure. (See also: *high-pressure hydrant.*)

Main line.
The telephone system connecting all firehouses with Radio and the head-quarters.

Master stream.
Water surging at maximum volume through a big line or ladder pipe.

Multiversal.
A high-volume nozzle mounted atop a fire engine. It can quickly be removed for redeployment at another location.

Nothing showing.
As firefighters arrive at firesite, they see nothing going on—no smoke, no commotion—and report back to Radio: "Nothing showing." (See also: *under investigation; smoke showing; working fire.*)

Operator.
An archaic term for *chief's aide.* In pre-radio days, the chief's operator remained at the corner box to communicate with the "alarm office" via Morse telegraphy. With typical firefighter intransigence, many still prefer term to *chief's aide.*

Oshkosh.
Enormous eight-wheel fire rig used to fight aircraft fires. It carries thousands of gallons of water and foam, as there are few hydrants at the airport.

Out the line.
A somewhat derisive term for the slower, less active firehouses in the Sunset and Richmond districts.

Pompier ladder.
Named for the firefighters of France, this strange-looking device can be hung from a window on its right-angle steel hook for an exterior descent to lower floors.

Probationary firefighter
(or: **probie**).
A new firefighter during his first year with the department, still learning the ropes during his probationary year.

Ready lines.
200-foot small lines on all engines, pre-connected to the pump, equipped with Akron fog nozzles, ready to go right through front door of burning building with no delay.

Rescue squad.
SFFD has two rescue squads, each consisting of a four-man team skilled in a wide range of techniques. They are the initial attack force at fires, expert in use of breathing apparatus. All members are scuba divers. Many have medical training, and are frequently called upon to use it. Their truck includes the Hurst "Jaws of Life" device, climbing and rappelling gear and other such implements. The squad is an elite duty; assignments are eagerly sought.

Scott Air-Pak.
It allows a firefighter to breathe for some 30 minutes inside a smoky building. A tank strapped on his back feeds compressed air into a face mask. (See also: *bottles.*)

Service squad.
A truck that responds to major blazes, loaded with extra Scott Air-Pak bottles and a compressor to fill more at the site. (See also: *Scott Air-Pak.*)

Small line.
A one-and-a-half-inch hoseline; it puts out less water than the three-inch big line. Used at lesser fires. (See also: *big line.*)

Smoke showing.
As firefighters arrive at a firesite, they see smoke—always indicating some immediate action is required—and report to Radio: "Smoke showing." This is the second most urgent report they can make. (See also: *nothing showing; under investigation; working fire.*)

Special call.
A call from a fire scene for companies or equipment not regularly assigned to the box.

Spot.
Periodic vacancy lists invite firemen to put in for changes in assignment. Once duly assigned to a given company, that job becomes a "spot" from which a firefighter can't be dislodged until he wants to move on. (See also: *tours.*)

Still.
Currently called a *unit dispatch.* A call for a single company to respond to a relatively minor incident. Back when bells signaled all boxes in firehouses citywide, these low-key dispatches were phoned in from the Comm Center—hence "still."

Tillerman.
The fellow who steers the rear end of the fire truck, turning his steering wheel in the "opposite" direction from what one does at the front end. At firesite, the tillerman becomes the *ladder pipe* operator when it is deployed. (See also: *ladder pipe.*)

Tours.
(Short for *tours of duty.*) Basically, San Francisco firefighters work a 24-hour shift followed by 48 hours off. Every fourth turn, it's 72 hours off, so that (with a few adjustments during the year) it rounds out to the equivalent of a 49-hour workweek.

Truck.
See *fire truck.*

Turnout gear.
The term for apparel worn to a fire, made of Nomex, a highly fire-resistant material capable of protecting a firefighter in high temperatures.

Under investigation.
As firefighters arrive at firesite, they see no smoke, no flame, but there is some commotion, some activity—perhaps somebody in the street, signaling them to a house—and they report to Radio: "Under investigation." (See also: *nothing showing; smoke showing; working fire.*)

Working fire.
As firefighters arrive at firesite, they see flames leaping from the building—indicating the fire is well under way—and report to Radio: "Working fire." This is the most urgent initial call a firefighter can make, often a prelude to calling for a second alarm ordering more men and equipment to the scene. (See also: *nothing showing; under investigation; smoke showing.*)

SAN FRANCISCO

FIRE DEPARTMENT